ANN CHUMBLEY & IAN WARRELL

Turner and the Human Figure

STUDIES OF CONTEMPORARY LIFE

TATE GALLERY

Foreword

Turner has frequently been characterised as an unsocial man, terse in conversation, poor in company and with little interest in his fellows. However, in practice he established close friendships with patrons, such as Fawkes, Egremont and Munro, while his sketchbooks are filled with closely observed studies of men, women and children at work, rest and play. From an early date such studies formed the basis for incident in his finished watercolours, or details in compositions such as 'Shipwreck' 1805.

A reassessment of Turner's interest in the human figure was initiated by Andrew Wilton, now Curator of the Turner Collection in his catalogue for the important exhibition of Turner watercolours at the British Museum in 1975. In recent years others have pursued this theme, notably Eric Shanes in his book on Turner's *Picturesque Views in England and Wales*, and, more recently, the Tate Gallery's own 1983 show of watercolours selected by Judy Egerton.

The exhibition explores Turner's use of the human figure and reveals his deep awareness of contemporary life. Like *Turner and Architecture* last spring, it focuses on a particular theme in Turner's work, which must be seen in the context of the permanent display of paintings hanging in the other rooms of the Clore Gallery. In contrast with *Turner and Architecture*, which was composed almost solely of material from the Turner Bequest, we have been able to fill gaps in our collection by means of three very generous loans: from the British Museum (cat. nos. 31, 37, & 43), the Courtauld Institute (cat. no. 4), and, most notably, the Victoria and Albert Museum, which has lent the watercolour of 'Plymouth' (cat. no. 53), an important work not exhibited outside that institution since it was bequeathed in 1882.

Ann Chumbley and Ian Warrell, who have selected the exhibits and written the catalogue, would like to thank Peter C. D. Brears, Director of Museums, Leeds City Museum; Dr Jeremy Cater of Royal Holloway and New Bedford College; Ian Dejardin of the Royal Academy Library; Dr Robert Forrester, Regional Officer, BTCV; as well as the staff of the British Museum Print Room and their colleagues at the Tate Gallery for their contributions to the realisation of the catalogue and exhibition. The exhibition and catalogue have been sponsored by Henry Ansbacher. We are most grateful to them for their generous support.

Nicholas Serota *Director*

Turner's Figures

'Landscape is of little value, but as it hints or expresses the haunts and doings of man'.[1] This comment, conveying as it does a sentiment fundamental to the Romantics, could very easily serve as a description of Turner's landscapes. It was made, in fact, by one of his most ardent followers, Samuel Palmer, and recognises an important characteristic of Turner's achievement as a landscapist.

Turner's output, which began as part of the popular topographical movement of the late eighteenth century, always retained an element of journalistic topography. Following well-established tradition, which had been exemplified in the watercolours of men like Paul Sandby and Turner's own master, Thomas Malton, he regarded the figure as an integral and vital element in the depiction of particular places. The scene in front of the burnt-out Pantheon (cat. no. 13) derives much of its effect from a carefully selected and arranged cast of figures, who provide a commentary on the disaster. The principle established in this early drawing was to remain a lifelong feature of his work.

Turner's is a comprehensive vision of human life, embracing every aspect of experience from the humorous and trivial moments of childhood to what Ruskin termed 'the labour and sorrow and passing away of men'.[2] He sought to depict not only figures drawn from contemporary life, but also the imaginary figures of classical myth. Many of Turner's paintings reflect his ambition to be judged by the high-minded standards of the Royal Academy, which under Sir Joshua Reynolds's leadership had proclaimed the supremacy of history painting over landscape and other branches of art. Turner adopted these standards, but was determined that they should be seen to apply equally to landscape. He therefore borrowed the aims, and many of the forms, of Richard Wilson, who had evolved a language of 'serious' landscape from the ideal landscapes developed by Claude and Poussin in the seventeenth century. His perception of the possibilities of historical landscape developed after his visit to Paris in 1802 where he noted the work of Titian and Poussin. In particular, the 'St Peter Martyr' of Titian was significant in affirming his own understanding that the meaning of landscape art was inseparably bound up in a union of figures and setting. In paintings throughout his life he achieved this balance so that his figures are much more than accessories to a fantastic setting: they are the protagonists of heroic dramas, building great civilisations, illustrating the myths which run through all human experience.

The wealth of drawings in Turner's sketchbooks demonstrates over and over again that he considered the figure worthy of repeated study. He would devote page after page to the costumes and professional appurtenances of the people he observed on his travels, recording them with omnivorous curiosity and an instinctive sympathy, the objective compassion of the great artist. He can convey as much of character and situation by a hasty sketch of a profile or a back as by a more detailed portrait (fig. 1). On two occasions he actually set aside a book specifically for notes on figures seen on tour: the *Scotch* or *Swiss Figures* sketchbooks (see TB LIX and cat. no. 74) contain studies of men and women in the costume of their countries, engaged in the gossip or workaday routines of their ordinary lives. Such collections of figures had been the stock-in-trade of the topographer for many decades, and indeed W. H. Pyne, in his *Microcosm* of 1803, was shortly to publish a series of such images which was to become the mainstay of many artists in the early nineteenth century. Turner's own fascination with individual habits or occupations was equally closely linked with his need to invent appropriate staffage for his views. The majority of his on-the-spot sketches for these note the topographical features alone; figures are introduced only at the stage of the finished work – though occasionally they are tentatively included in preparatory colour studies (cat. no. 25). They are invented with such a strong sense of the specific relevance of figures to landscape that it is often difficult to believe that they do not record incidents witnessed by Turner in the places he is depicting. He was surely well aware of the principle enunciated to the young John Constable by J. T. Smith: 'you cannot remain an hour in any spot, however solitary, without the appearance of some living thing that will in all probability accord better with the scene and time of day than will any invention of your own'.[3] With the exception

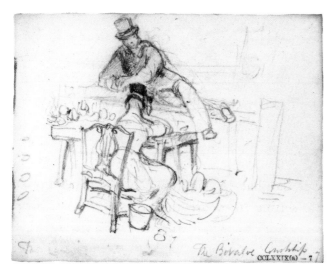

fig. 1 'The Bivalve Courtship' *c.*1832, pencil 85 × 111 ($3\frac{5}{16} \times 4\frac{3}{8}$) (TB CCLXXIX (a) f. 7)

of a few of the early Swiss watercolours, which celebrate the bleak hostility of the higher mountain passes, Turner hardly ever made finished drawings of places which did not require for their full expression the presence of figures – and often, of figures in large numbers.

fig. 2 'Oxford High Street'
1810, oil on canvas
685×1003, ($26\frac{15}{16} \times 39\frac{1}{2}$)
Loyd Collection

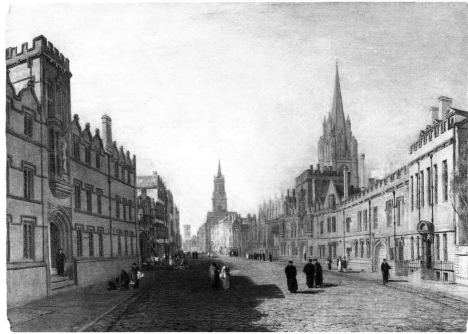

A well-documented example of Turner's sense of the importance of particular figures to particular places is the oil painting of 'Oxford High Street' (BJ 102; fig. 2). Its genesis can be traced in a series of letters from Turner to his engraver, James Wyatt, and it is clear that from the outset he intended to include figures in this composition. One letter to Wyatt lists the figures already introduced, and describes the minutiae of their costumes, confirming the importance of the notes about clothes in his sketchbooks. But Turner is not content to provide merely local colour. He questions Wyatt closely on the behaviour of his principal figures, worrying about apparently insignificant details such as whether a Bishop might be shown crossing the road while in conversation. The purpose behind Turner's rigorous attention to social and physical detail lies in his desire to provide as accurate a depiction of his whole subject as possible – 'to be *right*'.[4].

The ambition to be 'right' informs even those works in which historical allusion is mixed with the presentation of contemporary circumstances, so that changes to the architecture in the Oxford painting are accounted for by workmen taking down an arch no longer present. Even on occasions

when Turner uses other people's material rather than his own, as when he asked Wyatt to list suggestions for types of figures to be introduced in another view of Oxford,[5] or when, for his view of *Leeds*, he seems to have based his figures on plates in a book of contemporary costume (see cat. no. 35), he fuses everything he has learned into a convincing, many-dimensional statement. In 'Crossing the Brook' (BJ 130; Gallery 106), for example, he has combined charming studies of his own two daughters with a Devon landscape transformed by his brush to evoke the hazy light of Italy.

Despite Turner's ability to achieve this kind of synthesis, his figures have been the subject of much critical comment. They have been compared (as indeed his pictures in general have been) to culinary delights such as currant buns, or poached eggs and sausages.[6] Alternatively, critics have dwelt on the 'round balls with four pink spots in them instead of faces'.[7] While Ruskin could make such observations as this, he was nevertheless among the first to recognise the virtues of Turner's figure drawing in relation to the presentation of landscape in his watercolours. In one passage he suggests that if one of Turner's figures were repainted by a first-rate figure artist it would immediately illustrate that the picture's 'truth of space was gone, that every one of its beauties and harmonies had undergone decomposition, that it was now a grammatical solecism, a painting of impossibilities, a thing to torture the eye and offend the mind'.[8]

Another perceptive nineteenth century critic, Henry Quilter, also justified Turner's figures by reference to their integral role in the landscape as a total composition:

> No doubt [the figures] are frequently, if you detach them from their places in the pictures, anatomically incorrect and artistically poor. But leave them where they are intended to be, and it is impossible to deny that they absolutely fulfil their artistic object, they are essential parts of the whole impression conveyed by the work in which they exist.[9]

It should also be pointed out in Turner's defence that many landscape painters have been criticised for their figure drawing, not least Claude. Perhaps it is precisely because of the vital importance of figures to Turner's whole approach to landscape that he has been so severely censored. In fact, as this exhibition will, it is hoped, demonstrate to the unprejudiced, Turner was far from being a clumsy draughtsman and is often very accomplished in his study of the figure. Of twentieth century critics, Andrew Wilton has argued most convincingly that Turner's work

represents a continuation of the great traditions of Northern European Gothic art, seeing Turner's humane realism as a descendant of the sometimes brutal honesty of Brueghel or Rembrandt.[10] The eighteenth-century obsession with the picturesque, as expressed by Gilpin, set out to 'pursue beauty in every shape ... admiring it in the grandest of objects, and not rejecting the humblest'.[11] The distance Turner had travelled from this notion is illustrated in the attitude of Thomas Hardy, who found, through an understanding of Turner's art, his own perception of the intrinsic 'beauty in uglinesss'.[12] Another novelist, E. M. Forster, allows his characters to ponder Turner's figures, acknowledging that what appears at first to be an unfortunate clumsiness is in fact a calculated reflection of real life where toil disfigures:

> 'Don't you know how Turner spoils his pictures by introducing a man like a bolster in the foreground? Well, in actual life every landscape is spoilt by men of worse shapes still'.[13]

As we have seen, Turner mastered the technical aspects of figure drawing. But it is evident that he was motivated by considerations other than the requirement that landscapes should be peopled by elegant staffage. Like his great contemporary Goya, with whom he has much in common in his treatment of the figure, he tries to present men and women as fragile and vulnerable: if they are ugly it is their labour that makes them so; if they appear clumsy or stupid, it is because man is and always has been clumsy and stupid in the face of the great questions of existence. It is Turner's all-embracing sympathy with the lot of the ordinary man that enables him to create heroic dramas from the description of everyday life.

In his later work his longstanding fascination with crowds becomes an insistent motif. Individual figures are absorbed into swarming masses which pervade the landscape as an elemental life-force wholly at one with its setting. These pictures, both oils and watercolours, are expansive celebrations of the unity of man and nature. Despite Turner's reputation as a pessimist, despite the many occasions when he paints the 'sorrow' of humanity, he rises in these works above any limited or short-term view of the human condition to present it as an organic and immutable element of the earth itself. Such visions confer a retrospective splendour and dignity on all the teeming aspects of mortal existence that he had so faithfully recorded throughout his life.

Pupil and Teacher: Turner in the Royal Academy Schools

While much of this exhibition focuses on Turner's depiction of human beings in their environment, it is also important to acknowledge his ability to draw from the nude, a skill acquired by hours of patient study in the Royal Academy Schools. Turner had been proposed for admission to the Schools by the historical and decorative painter J. F. Rigaud (1742–1810). Like all applicants, Academy rules dictated that he submit a drawing made as a copy of an Antique sculpture. If this was considered acceptable by the Keeper, a further drawing was to be made from a cast in the Royal Academy collection. Upon the second drawing receiving official approval the student was admitted to the Antique or Plaister Academy to continue this line of study.

Turner began his education there in December 1789, and remained a pupil until almost four years later, his latest signature in the Plaister Academy register being dated 8 October 1793.[1] Despite the length of time he spent there, with over one hundred and thirty attendances recorded in the Registers,[2] very few drawings have been preserved recording his development at this point in his career. Those we do have, such as cat. nos. 1 and 2, demonstrate that he attained more than a perfunctory competence in this field, with several of the casts drawn under ambitiously dramatic lighting.

He must also have used the resources of the Royal Academy Library, studying and copying engravings. A couple of drawings in the Turner Bequest point to a familiarity with Andreas Vesalius's *De Humani Corporis Fabrica*, as do three pencil outlines in an early sketchbook now in the Princeton University museum.[3] He also seems to have made use of the work of his contemporaries, and while still in the Academy Schools acquired a group of anatomical drawings by Charles Reuben Ryley (1752–1798). It is doubtful whether this group of drawings had any great influence on Turner's work, but he evidently valued them, listing them in an inventory of his collection of works by other artists in about 1812.[4] Turner also retained an interest in the Plaister Academy once he had become a full Academician, returning as Inspector of the Cast Collection for the years 1820, 1829 and 1838, while in 1842 he donated a copy of Michelangelo's *Torso Belvedere*.[5]

Students graduated from the Plaister Academy to the Academy of Living Models, or Life Class, upon achieving the requisite standard of

proficiency at cast copying. It was laid down that they should study in the two academies for a combined total of six years (seven from 1792). Turner's first recorded attendance in the Life Class was on 25 June 1792, soon after he had exhibited 'The Pantheon' (cat. no. 13), although it appears he continued to attend the Plaister Academy for at least another year.

The rules covering practice in the Life Academy set out two terms of study: the Winter Academy ran from Michaelmas to April, while the Summer Academy began in May and continued until the end of August. The models were 'men and women of different characters':[6] two were employed per week, taking three of the two-hour evening sessions each. These classes were available 'free to all Students who shall be qualified to receive advantage from such studies'. A further proviso ensured a degree of respectability, so that students had to be at least twenty, or married, before they were eligible to draw from the female model.[7] Turner's first attempt at drawing from the female nude can perhaps be identified as the colour study in the *Wilson* sketchbook, which he was using from 1796 when he was twenty-one.[8]

By the end of 1799 Turner had attended the Life Academy over one hundred times,[9] and had been elected an Associate of the Royal Academy, an achievement that marks the end of his apprentice years. Ever keen to teach others, upon being elected a full Academician in 1802, he applied for the post of Visitor to the Academy Schools. However, this attempt to improve upon the teaching he had received under the sculptor Joseph Wilton was unsuccessful.

The Turner Bequest contains a group of drawings dating from the years of Turner's attendance at the Life Academy, but the importance of this experience to his work as a whole can only fully be appreciated by an examination of the academy studies that recur in the sketchbooks throughout his career to a date as late as about 1844. In these the models are mostly shown independent of their setting, although on several instances Turner made notes, as in the drawing on display here, of the room itself (cat. no. 11). The Academy and its Schools occupied part of Somerset House until 1837, when it moved to the new National Gallery building in Trafalgar Square.

On occasions Turner's academic studies seem to have triggered an erotic response, which can be seen in variations on traditionally erotic themes such as Leda and the Swan,[10] or in more explicitly sexual depictions of the female nude (see cat. nos. 8, 10 and 12).[11] Other drawings suggest that he was stimulated by the naked model to reflect on his relationship with Sarah Danby, his mistress from 1799 until about

1815. For example, the *Lowther* sketchbook, in use around 1809, contains a number of studies of nude women (fig. 3), as well as the inscription, 'Woman is doubtful love'.[12]

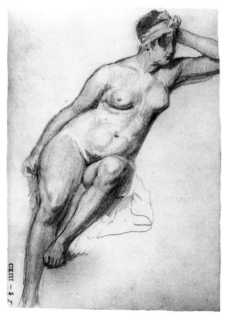

fig. 3 'Study of a Female Nude' 1809, pencil 82 × 114 $(3\frac{3}{16} \times 4\frac{1}{2})$ (TB CXIII f. 5)

He was finally appointed to the post of Visitor to the Academy Schools in 1812, ten years after his first application. According to the Academy rules it was the responsibility of the Visitors to 'attend the Schools by rotation, each a month, to set the figures, to examine the performance of the Students, to advise and instruct them, to endeavour to form their taste'.[13] Turner was to be Visitor to the Life Academy eight times,[14] and seems to have been most influential during the 1830s. As with the lectures he gave as Professor of Perspective from 1811, he may well have prepared himself thoroughly by wide reading for his role as Visitor. One sketchbook, for example, contains a pencil outline of a female nude alongside which he has drawn an idealised serpentine 'Line of Grace' (fig. 4), suggesting that the drawing records an attempt to demonstrate the theories proposed in Hogarth's *Analysis of Beauty*.

Among many novel features he introduced the practice of setting models against a white cloth to heighten reflections and thereby 'infuse new life into the practice of the students'.[15] But it was his innovative posing of the model that attracted most approval from his colleagues. The study of a female nude standing beside a cast of the Venus de Medici by William Etty, exhibited here (cat. no. 4), illustrates an anecdote recalling how Turner had placed 'a female in her first period of youthful womanhood' alongside a cast of the Venus de Medici. The Redgrave brothers, who

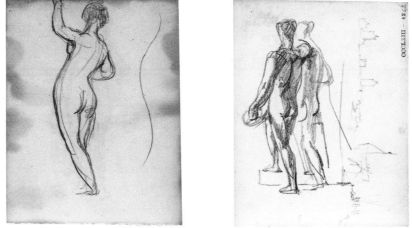

fig. 4 (left) 'Study of Female Nude and Hogarth's 'Line of Grace' c. 1831, pencil 73 × 92 ($2\frac{7}{8} \times 3\frac{5}{8}$) (TB CCLXIV f. 3 verso)

fig. 5 (right) 'Study of Two Nude Figures' c. 1844, pencil 76 × 98 ($3 \times 3\frac{7}{8}$) (TB CCCLXIII f. 42)

record this incident in their *Century of Painters of the English School*, considered the idea 'original and very instructive: it showed at once how much the antique sculptors had refined nature'.[16] As noted in cat. no. 4, Turner's introduction of figure groupings instigated a brief period in which the poses of the models became compositions includings 'props' and 'scenery'. A drawing in one of the late sketchbooks in the Turner Bequest records an incident of this sort with two figures set in walking postures – although it is possible that, as in the Etty drawing, one is actually a cast from the Antique (fig. 5).

Turner's visits to the Royal Academy Schools also ensured that he had the material with which to invest his classical compositions with specific meaning. For example, a story concerning *The Golden Bough*, exhibited in 1834 (BJ 355, Gallery 104), records that when in need of figures for the foreground he went to the Life Academy and studied a nude only to find that his sketch was the exact size required for his painting. In his haste to complete the picture the sketch was cut out and stuck onto the canvas, without being actually painted. This omission was only discovered after Turner had sold the picture, whereupon he remedied the deficiency.

Turner's commitment to the Academy Schools is consistent with his loyalty and dedication to all duties connected with the Academy. He persisted in attending the Life Academy in December 1837 despite the cold and damp conditions,[17] and continued as a student at the class even in his late sixties.[18] The continued relevance of the principles of figure study emphasizes yet again the centrality of figures to his concept of landscape; it was precisely this kind of discipline which provided him with the sure foundation on which his art could flourish.

Footnotes

TURNERS FIGURES

[1] Letter to Hannah Palmer, 11 May 1856. Quoted in Andrew Wilton's Introduction to Eric Shanes, *Turner's Picturesque Views in England and Wales*, 1979, p. 9

[2] Ruskin, *Works*, vol. VII, p. 385–6

[3] Quoted in Andrew Wilton's catalogue essay for the 1975 exhibition *Turner in the British Museum*, p. 17

[4] Gage, *Collected Correspondence of J. M. W. Turner*, 1980, p. 40, Letter 30, Feb 28 [1810]

[5] Gage, 1980, pp. 51–2, Letter 44, March 6, 1812

[6] Kenneth Clark, quoted in Andrew Wilton's article, 'Sublime or Ridiculous? Turner and the Problem of the Historical Figure', 1982, p. 361, fn 43, and p. 368–70

[7] Ruskin, *Works*, vol. III, p. 325–6

[8] Ibid

[9] Henry Quilter, *Sententiae Artis*, 1856, pp. 152–3: quoted in Andrew Wilton's catalogue essay for the 1974 exhibition *Turner in the British Museum*, p. 24

[10] Andrew Wilton, op. cit., 1982, p. 366

[11] W. Gilpin, *Three Essays*, 1792, 'Vox faucibus haeret'

[12] J. B. Bullen, 'Thomas Hardy and Turner', 1988, p. 11

[13] E. M. Forster, *The Longest Journey*, 1907, Penguin edition, p. 75

PUPIL AND TEACHER

[1] A. J. Finberg, *Complete Inventory of the Turner Bequest*, vol. 1, p. 7. For examples of Turner's signatures at this date, see Curtis Price 'Turner at the Pantheon Opera House 1791–2', *Turner Studies*, winter 1987, vol. 7, no. 2, pp. 2–8

[2] A. J. Finberg suggests a total of 137 attendances, although this excludes two periods for which Registers were missing, a figure confirmed by Robin Hamlyn, 'Turner and the Royal Academy', p. 609

[3] See Robin Hamlyn's article, 'An Early Sketchbook by J. M. W. Turner'; and ff. 17, 18, 19 of the sketchbook, reproduced there.

[4] See the *Woodcock Shooting* sketchbook, TB CXXIX f. 8, which lists '19 Academy figures by Ryley RA'

[5] Gage, 1987, p. 33

[6] Much of this information can be found in C. Hutchison's article, 'The Royal Academy Schools, 1768–1830', from page 127 following.

[7] Ibid, p. 129

[8] See TB XXXVII p. 19. The whole of this sketchbook has been reproduced in facsimile by Tate Gallery Publications.

[9] A. J. Finberg, *Inventory*, vol. 1, p. 24.

[10] See the *Windmill and Lock* sketchbook, TB CXIV f. 2

[11] See also *Finance* sketchbook, TB CXXII f. 37; *Rome to Florence* sketchbook, TB CXCI f. 91, verso; *Academy Auditing* sketchbook, TB CCX(a); *Cologne and Mayence* sketchbook, TB CCXCI (a) ff. 34 verso, 35; *Lintz, Salzburg etc* sketchbook, TB CCCXI ff. 38 verso, 39.

[12] TB CXIII f. 59.

[13] Hutchison, p. 126

[14] 1812, 1813, 1830, 1831, 1834, 1835, 1837, 1838

[15] *Report of the Commission . . . on the Royal Academy*, 1863, p. 65: quoted in the catalogue of the 1974 Royal Academy exhibition, p. 181

[16] Richard and Samuel Redgrave, *A Century of Painters of the English School*, 1866, vol. 2, pp. 93–4

[17] Gage, 1980, Letters 214, 215, pp. 168–9

[18] Ibid, Letter 265, p. 197

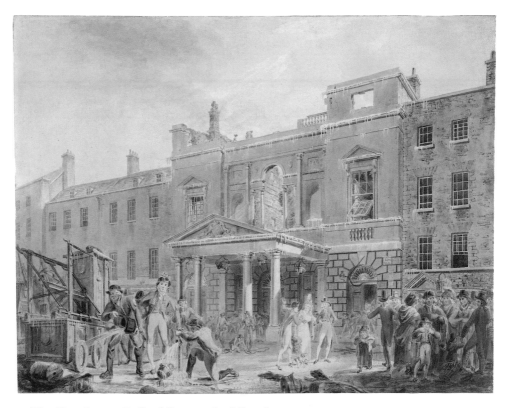

13 **The Pantheon, Oxford Street, the Morning
 after the Fire** 1792

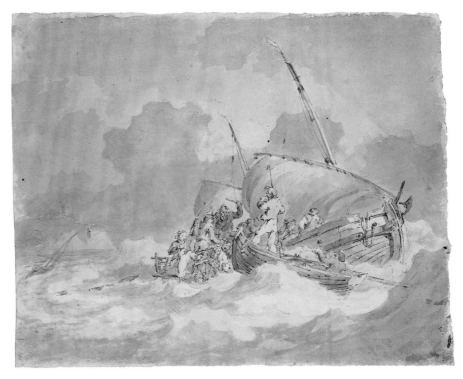

15 **Sailors getting Pigs on Board** *c.* 1794

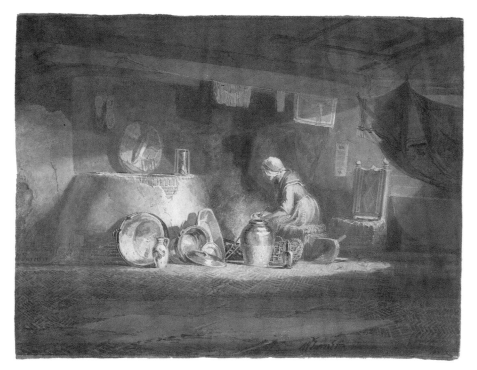

16 **An old Woman in a Cottage Interior** 1796

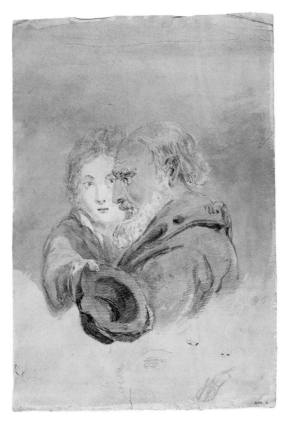

18 **An old bearded Man seen in Profile with a
Boy reaching past him, holding a Hat** 1796–7

21 **Interior of French Church with Figures** *c.* 1830

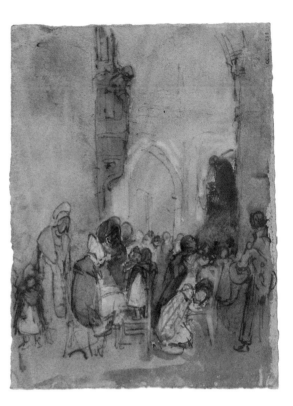

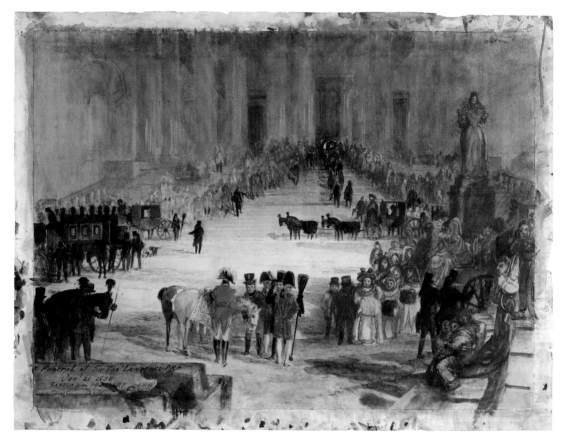

22 **Funeral of Sir Thomas Lawrence: a Sketch from Memory** 1830

25 **High Street, Oxford** 1830–5

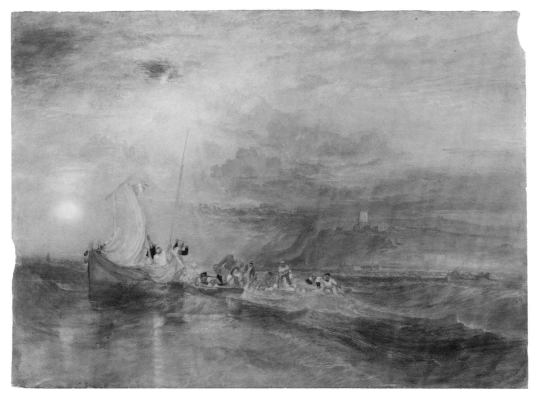

39 **Folkestone from the Sea** *c.* 1832

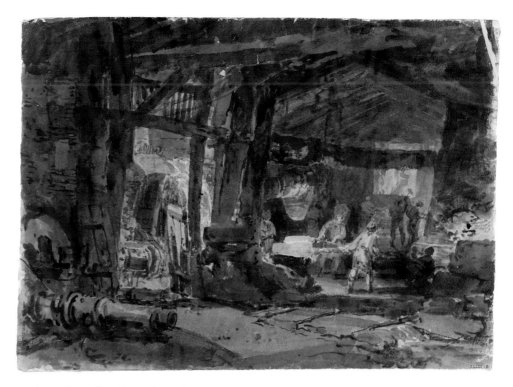

40 **Interior of an Iron Foundry** *c.* 1797

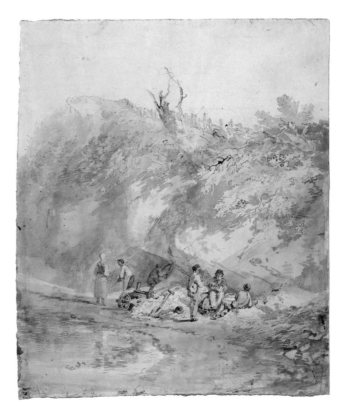

41 **Workmen lunching in a Gravel Pit** *c.* 1797

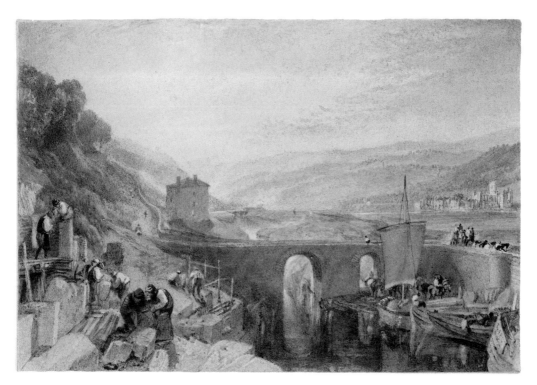

45 **Kirkstall Lock** 1824–30

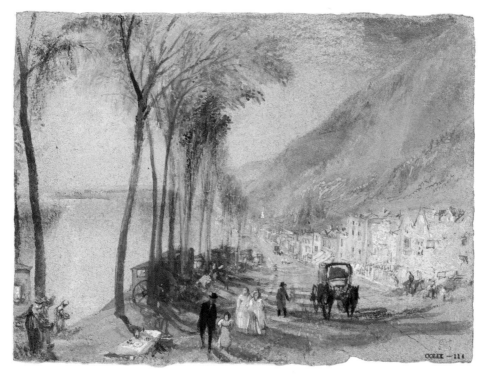

47 **Between Mantes and Vernon** c. 1832

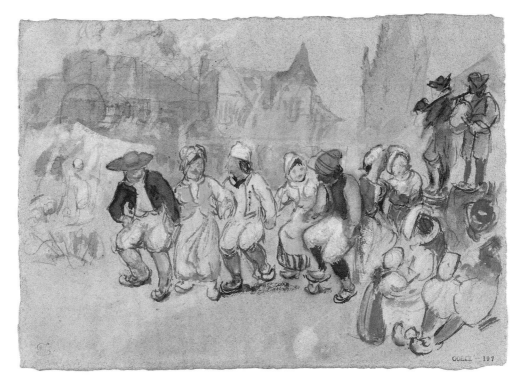

50 **French Peasants dancing** 1826–30

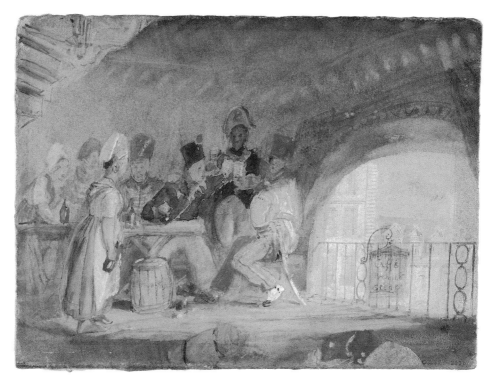

61 **Soldiers in a Tavern** *c.* 1829

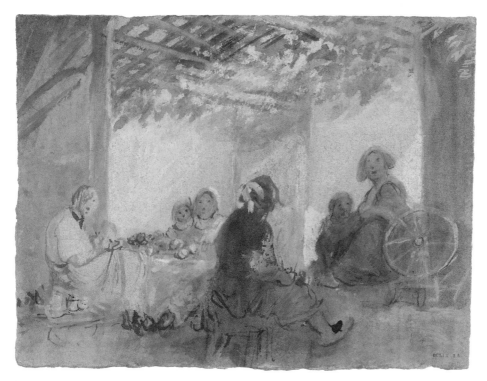

62 **The 'Al Fresco' Meal** *c.* 1830

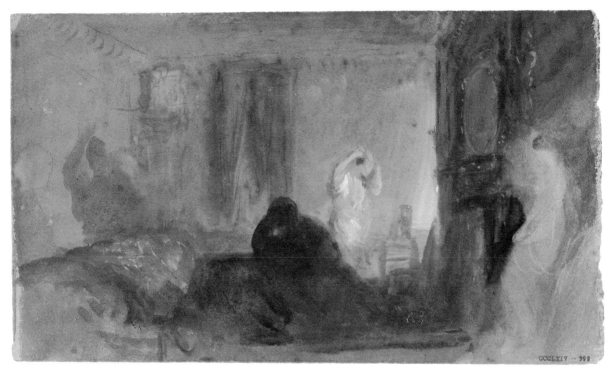

65 **Three Figures in a darkened Interior** *c.* 1832

CATALOGUE

Abbreviations

'BJ' Martin Butlin and Evelyn Joll, *The Paintings of J. M. W. Turner*, 1984 (revised edition)
'R' W. G. Rawlinson, *The Engraved Work of J. M. W. Turner, R.A.*, 2 vols., 1908
'TB' Turner Bequest items as listed in A. J. Finberg, *A Complete Inventory of the Turner Bequest*, 1909
'W' Andrew Wilton, *The Life and Work of J. M. W. Turner*, 1979
Other works referred to are listed in the Bibliography, p. 62.

All measurements are given in millimetres followed by inches in
brackets, with height before width.
Works illustrated in colour are marked*

Academy Studies

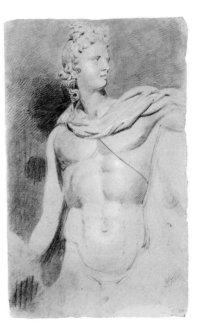

1 Study of the Head and Torso of the Apollo Belvedere ?1792
Black and white chalks on laid buff-grey paper
419×269 ($16\frac{1}{2} \times 10\frac{9}{16}$)
Turner Bequest; V D
D00057

Turner was admitted to the Royal Academy Schools at
the age of fourteen in December 1789. On entering the
schools all students spent several years in the 'Plaister
Academy' perfecting the technique of copying from the
casts taken of antique sculptures. This study, from a cast
of the Apollo Belvedere, is one of four of this subject in
the Turner Bequest.

The verso of this sheet has a recipe in Turner's
handwriting for the etching process suggesting that the
young artist was already keen to widen his technical
skills.

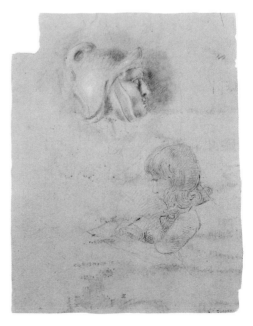

2 Helmeted Head in Profile; and a Study of a Boy drawing ?1792–3
Black, white and red chalks and stump
338×274 ($13\frac{5}{16} \times 10\frac{3}{4}$)
Turner Bequest; V R verso
D40220

While in the Plaister Academy Turner made many
copies of casts in the Royal Academy collection includ-
ing those of the Venus de Medici, the Vatican
Meleager, the Discobolus and the Fighting Gladiator.

This drawing of an unidentified Gladiator's head was
probably made in the last year of his study in the
Plaister Academy. The sketch of one of his fellow
students, deeply engrossed in his work, suggests
Turner's frustration with merely copying casts, and his
ambition to move on to the next stage of his apprentice-
ship, the Life Class.

3 **Academy Study of a standing Male Nude, with right Arm raised, seen from behind** ?1797
Black and white chalks and red bodycolour on laid blue paper
514×349 ($20\frac{1}{4} \times 13\frac{3}{4}$)–uneven
Turner Bequest; XVIII G
D00202

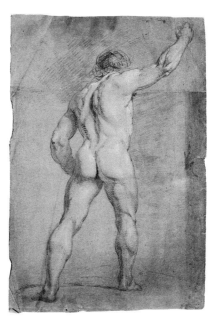

After graduating to the Academy of Living Models, or Life Class, in June 1792, Turner became a regular attender of the evening sessions, a habit he was to continue throughout his life, even when he was not there in an official capacity.

The models in the Life Class were often set in poses echoing Classical prototypes, an influence which can be found in the history pictures Turner was to exhibit at the Royal Academy all his life.

4 WILLIAM ETTY (1787–1849)
Female Nude standing beside a Statue of the Venus Pudica *c.* 1835
Black, red and white chalk on brown paper
563×388 ($22\frac{3}{16} \times 15\frac{1}{4}$)
Courtauld Institute Galleries, London (Witt Collection, No. 3225)

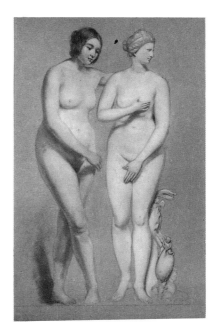

This study by William Etty, a painter famed for his depictions of the nude, illustrates the influence Turner exerted in the years he was Visitor to the Life Class at the Royal Academy. He had first applied for the post in 1802, the year he was elected a Royal Academician, but was unsuccessful in this attempt to remedy the neglects of the teaching at that time. However, between 1812 and 1838, he was to occupy the post of Visitor on eight occasions. Contemporary accounts record how successful the students found his methods of teaching.

Daniel Maclise (1806–1870), for instance, recalled that once Turner 'arranged a female form in the same attitude as the *Venus de Medici*; standing by a cast of the latter brought in for the purpose'. This study was apparently made on that occasion, Etty's drawing highlighting the differences between the classical ideal and the beauty of living flesh. Other evenings under Turner's guidance at the Life Class saw the 'Discobolus of Myron' placed beside an athletic soldier, or the 'Lizard Killer' beside an adolescent. Writing of this some years later, the Redgrave brothers noted with admiration that it was 'a capital practice, which it is to be regretted has not been continued', and that the schools were always better attended when Turner was supervising. Other Visitors chose to set their models in elaborate poses reminiscent of Turner's: Constable apparently set a female model in the pose of Eve

tempted, in front of a laurel tree laden with orange fruit, while Etty contrived complicated groupings of models as dancing Graces, as Gladiators, or as Mother and Child.

Like Turner, Etty found renewed stimulation in his visits to the Life Class and returned there even when not a Visitor, much to the dismay of his colleagues. The admiration Etty felt for Turner was reciprocated; for instance, it seems likely that Etty's painting, 'Hero and Leander' (on display in Gallery 9 of the main Tate building) may have stimulated Turner to paint his own canvas 'The Parting of Hero and Leander' (BJ 370; Gallery 104).

Sketchbooks

5 *Academical* sketchbook 1798
Study of a seated male nude holding a staff in his right hand
Pencil, watercolour and bodycolour on blue paper prepared with a red-brown wash
216×140 ($8\frac{1}{2} \times 5\frac{1}{2}$)
Turner Bequest; XLIII f. 6
D01822

This sketchbook contains thirteen Academy studies made on blue paper prepared with a wash of red-brown watercolour. Other openings include studies of the same model (ff. 4 and 6), a closely-observed sketch of a male back (f. 12), and a couple of Turner's earliest female nude studies with the model posed as Andromeda (ff. 3a and 4). On this sheet Turner has begun with a pencil outline using the watercolour and bodycolour to convey the weight of flesh and to model the light and shadows.

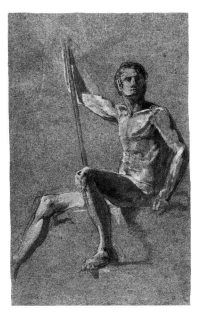

6 *Dolbadarn* sketchbook 1799–1800
A prostrate female figure
Pencil and watercolour
80×133 ($3\frac{1}{8} \times 5\frac{1}{4}$)
Turner Bequest; XLVI f. 116 verso
D02169

The poses of the models Turner studied at the Life Academy often served for his historical compositions. This and the following page can be related to 'The Fifth Plague of Egypt', a picture Turner exhibited in 1800, which is now in the Indianapolis Museum of Art (BJ 13). Other figures for the composition can be found in the *Studies for Pictures* and the *Calais Pier* sketchbooks (TB LXIX f. 22; TB LXXXI f. 25).

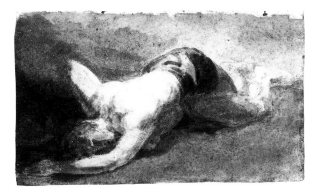

7 *Academies* sketchbook ?1804
Academy study of the back of a reclining female nude
Pencil and some watercolour
$73 \times 114 \left(2\frac{7}{8} \times 4\frac{9}{16}\right)$
Turner Bequest; LXXXIV f. 36
D05209

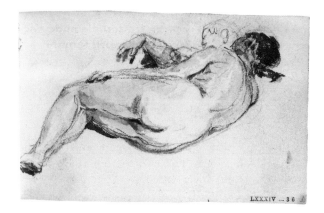

This sketchbook was in use some time after Turner had become a full Academician, and is one of the most extensive records in the Turner Bequest of his activity as a draughtsman of the nude, with over fifty subjects relating to this theme. Although Turner was not to become a Visitor at the Life Class until 1812, the book demonstrates that he still found such exercises an important discipline. The many studies in the book most probably result from only a couple of sittings in the Academy. Indeed, it is possible to recognise the same model on many of the sheets and to trace the same pose from a number of different angles. The drawing seen here shows an understanding of the movement of the body in the two positions of the head, as well as illustrating Turner's concern to suggest the play of light over the form.

8 **Sheet of erotic figure subjects** *c.* 1805
Pencil and sepia wash
$267 \times 368 \left(10\frac{1}{2} \times 14\frac{1}{2}\right)$
Turner Bequest; CCCLXV A
D40021

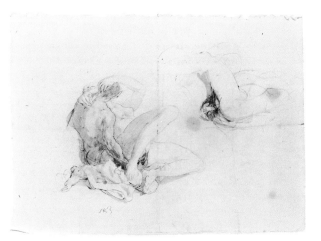

These drawings are executed in the 'Old Master' technique Turner favoured in the early years of the century in his studies for the 'Grand Manner' compositions he was showing at the Academy; but here his intention seems to have been one of private gratification rather than preparation for a more developed work.

9 *Hastings to Margate* sketchbook *c.* 1815
 **Academy Studies: a standing female nude; the
 back of the model's head; a draped female
 figure**
 Pencil
 $154 \times 89 \left(6\frac{3}{32} \times 3\frac{1}{2}\right)$
 Turner Bequest; CXL ff. 6 verso, 7
 D10421, D10422

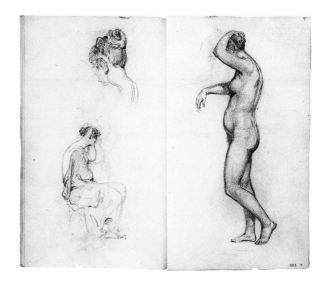

Although this sketchbook is mainly concerned with the
kind of sketching tour Turner often undertook, and is
inscribed on the cover 'Richmond Hill/Coast from
Hastings to Margate', it also contains a number of
studies obviously made at the Life Class. As well as this
beautifully detailed study, there are two other large-
scale drawings of the standing model on the preceding
pages (ff. 5 and 6). In this sketch Turner has paid
particularly close attention to the head and back of the
neck of the model, while on f. 6 he has made an equally
careful separate drawing of the model's left foot. The
draped model on the left-hand page of this opening is
also studied in a sheet of three sketches earlier in the
book (f. 5 verso). Another group focuses on a crouching
female form, her arm out-stretched as if begging (ff. 65,
70, 72, 73).

10 *Paris, Seine and Dieppe* sketchbook *c.* 1821
 **Reclining nude, draped with a red cloth
 Pencil, watercolour and bodycolour**
 $113 \times 188 \left(4\frac{7}{16} \times 7\frac{3}{8}\right)$
 Turner Bequest; CCXI f. 28 verso
 D18568

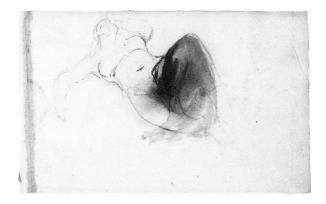

Along with French scenery recorded during Turner's
visit to France in 1821, this sketchbook includes pencil
outlines related to the 'Fairfax cabinet' at Farnley Hall.
Turner had made drawings of this for Walter Fawkes
some time around 1815, which suggests that the book
may have been in use over a number of years. Other
pages contain detailed costume notes, such as that on
f. 15 which recalls a 'Purple cap with White border',
and large groups of people engaged in their work. For
example, f. 25 verso depicts a scene of bustling activity
with French soldiers as well as many women going
about their business.

 This study of a draped nude shares an affinity with
notes Turner made in the *Academies* sketchbook
(cat. no. 7), the draped figure being a subject in the Life
Academy, although here the concentration on the
warm redness of the cloth and flesh suggest a more erotic
intent.

11 *Life Academy* (1) sketchbook *c.* 1832
The Life Class at the Royal Academy
Pencil
85×111 ($3\frac{3}{8} \times 4\frac{3}{8}$)
Turner Bequest; CCLXXIX(a) ff. 51 verso, 52
D27458, D27459

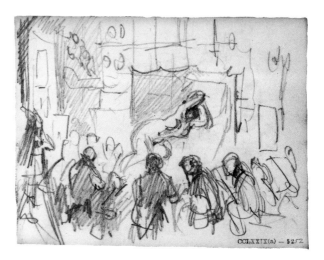

Turner served as a Visitor to the Life Class on several occasions in the 1830s. This sketchbook, dating from the early years of that decade, contains three sketches of the Life Academy itself (f. 20 verso, ff. 51 verso, 52 and ff. 58 verso, 59), the last of which is inscribed 'Visitor waiting [?] for the Model'. Like another sketchbook of this date, which follows the changing pose of the model (TB CCLXXIX(b)), the book is filled with outlines, and some more heavily worked studies, of the young woman seen posing here. At least one sheet depicts a pose almost identical to that drawn here (ff. 26 verso and 54 verso).

Other pages show figures and fish associated with marine scenery, and on f. 7 there is a little genre scene of a man with an oyster-seller, inscribed 'The Bivalve Courtship' (Fig. 1; see John Gage, 1987, p. 218).

12 *Colour Studies* (1) sketchbook *c.* 1834
Reclining female nude
Pencil and watercolour
76×102 (3×4)
Turner Bequest; CCXCI(b) f. 54 verso
D28869

This study of a reclining female nude leaves little doubt that its motive was erotic, the intention being made overt in the directness with which Turner has emphasized the genital area with a bold slash of red. The book was apparently in use during the early 1830s and contains a series of colour studies set in a darkened bedroom. On other openings, the woman is illuminated by warm light as she reclines on the bed. Several pages show two figures entangled. On f. 38 for example, the couple appear embracing as Titianesque lovers, the male dark and swarthy to highlight the pale beauty of the female figure.

Turner's Treatment of the Human Figure, 1792 – 1842

13 **The Pantheon, Oxford Street, the Morning after the Fire***
Exhibited RA 1792
Pencil and watercolour
516×640 ($20\frac{1}{4} \times 25\frac{1}{4}$)
Turner Bequest; IX A
DOO121
W. 27

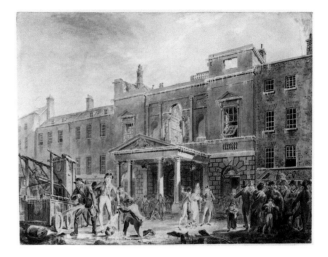

The first watercolour Turner exhibited at the Royal Academy in 1790, 'Lambeth Palace' (w. 10), had shown a confident deployment of a range of figures engaged in their daily activities. Over the years that followed Turner drew equally boldly treated topographical subjects, with the figure very much at the centre of interest. In 'Cote House, near Bristol' (w. 21), for example, the figure of a gamekeeper interrupts the view of the house, but stands pointing towards it, inviting the spectator to follow his directions to the real subject. Such devices were a standard part of late eighteenth century topography. However, when Turner exhibited this drawing of the Pantheon, showing the theatre the morning after a fire had destroyed the interior, he had reached a more mature understanding of how carefully introduced figures can point up the significance of a view. Turner is now known to have worked as a scene-painter at the theatre, so the subject must also have had a personal importance for him.

He took considerable trouble to recreate the perspective of the building accurately, basing his study on a squared-up sketch (TB CXCV 156). His attention to the architecture is complemented by a concern for the human activity: the grouping of people distracted from their daily lives by the spectacle is well-observed and balanced by the activity of the fire-fighters cleaning up after quenching the fire. Turner also notes the jostle of those eager to witness the effects of disaster as they push to see inside the ruined building.

Another watercolour in the Turner Bequest shows the burnt-out interior (TB IX B) and can be compared with its finished version where Turner enlivens the scene by including figures among the destruction (w. 28).

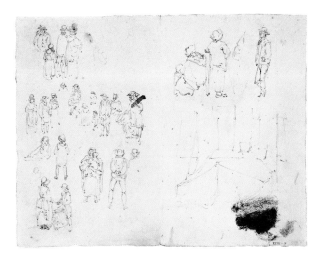

14 **Studies of Figures and of Fairground Tents
and Banners** 1793-4
Pencil, the sheet folded vertically down the centre;
a smear of dark green oil paint
213×275 ($8\frac{3}{8} \times 10\frac{13}{16}$)
Turner Bequest; XXIII F
D00380

Turner adopted a lifelong habit of noting the figures he
saw, most often recording his observations in sketch-
books. Alternatively, as in the case of this sheet, he took
loose pieces of paper, which were folded to facilitate easy
carriage on his travels. Studies like this were referred to,
along with an outline sketch of the surrounding build-
ings in the *Matlock* sketchbook (TB XIX f. 21), to create a
fully realised picture of a fair in the Midlands market-
town of Wolverhampton (W. 139). He notes the poses of
figures watching the street entertainment as well as the
two drummers participating in the occasion, and
observes, with no cloying sentiment, the plight of the
one-legged man on crutches. Turner's lifelong enjoy-
ment of the bustle of fairs can be seen in many other
watercolours including 'Louth' (cat. no. 31).

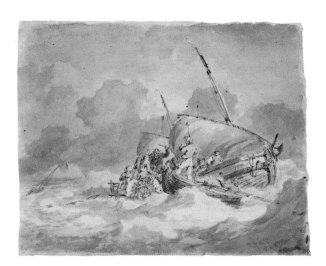

15 **Sailors getting Pigs on Board*** *c.* 1794
Pencil, pen with brown and black ink and
watercolour
216×275 ($8\frac{1}{2} \times 10\frac{13}{16}$)
Turner Bequest; XXIII T
D00394

This is one of the earliest of Turner's studies to focus on a
storm at sea and its effects. The prevailing conditions
are suggested by light washes of watercolour which
economically create a setting for the subject of the
drawing, a comic record of sailors attempting to haul
some obstreperous pigs on board a small boat in choppy
conditions.

Turner approaches the subject in an animated
manner close to that of Thomas Rowlandson, the
exuberent caricaturist, whose lively sense of the ridicu-
lous Turner evidently shared.

16 An old Woman in a Cottage Interior*

Exhibited RA 1796
Pencil and watercolour with a little scraping-out
199×271 $(7\frac{13}{16} \times 10\frac{11}{16})$
Turner Bequest; XXIX X
D00729
W. 141

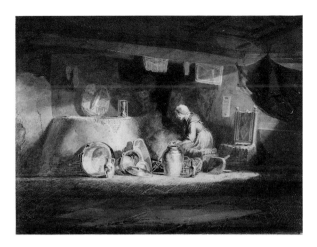

Along with a pencil study in the *Marford Mill* sketch-book (TB XX f. 35), this watercolour was thought in the nineteenth century to be a portrait of Turner's mother as she worked in the kitchen of their home in Maiden Lane, Covent Garden. However, it has been identified as the 'Internal of a cottage, a study at Ely', which Turner exhibited at the Royal Academy in 1796.

Throughout his career Turner was interested in depicting the figure in darkened interiors (see cat. nos. 21, 63, and 65). One of his earliest drawings shows a group of children nursing a cat in a kitchen lit only by the flickering light of the fireside (TB XVII L; Wilton 1979, p. 26 repr). The strong chiaroscuro there and in this drawing are perhaps influenced by the work of Joseph Wright of Derby.

This study also shows a debt to the interior scenes of seventeenth-century Dutch art, examples of which Turner may have seen at this time in the collections of his patrons. Another borrowing from Dutch art may be the comment on death and transience, or *memento mori*, present in the conspicuously placed hour-glass.

17 Two Soldiers talking *c.* 1796–7

Pencil, black chalk and watercolour
347×243 $(13\frac{5}{8} \times 9\frac{9}{16})$
Turner Bequest; XXIX P
D00721

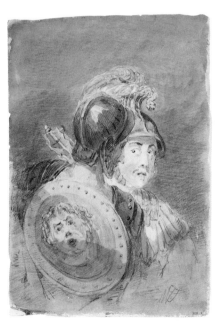

Both this and cat. no. 18 have the feeling of student drawings and are unusual as studies of facial expression. No obvious historical or mythological subject-matter suggests itself for the sheet, although Turner made somewhat similar studies of figures in historical armour in the *Wilson* and *Dinevor Castle* sketchbooks (TB XXXVII f. 10 and TB XL f. 13). His inspiration most probably came from a tradition of capricious subjects of men of arms – soldiers, mercenaries or bandits – that reached back from John Hamilton Mortimer and his follower Ryley (see p. 12) to Salvator Rosa and Jacques Callot.

18 **An old bearded Man seen in Profile with a
Boy reaching past him, holding a
Hat*** *c.* 1796–7
Black chalk, pencil and watercolour
344 × 242 ($13\frac{9}{16} × 9\frac{1}{2}$)
Turner Bequest; XXIX O
D00720

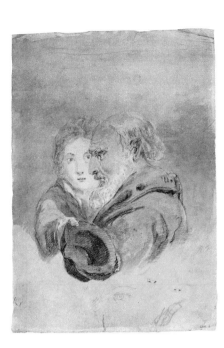

With its companion drawing, this study was perhaps
made as an exercise during the years Turner was a pupil
in the Life Academy; and like cat. no. 17, it seems to
have no obvious literary subject. However, the boy's
face here does bear a striking resemblance to Turner's
self-portrait of a few years later (BJ 25; Gallery 103).
Turner is known to have made only three self-portraits,
all dating from his adolescence, but it does not seem
entirely improbable that he should have shown himself
in this kind of academic context.

19 **Study for a Figure Subject** *c.* 1804–10
Pen and brown ink with some chalk on brown
paper
223 × 328 ($8\frac{9}{16} × 12\frac{7}{8}$)
Turner Bequest; CXIX S
D08206

Turner's training at the Royal Academy ensured that
he was familiar with the opinions of Sir Joshua Rey-
nolds concerning the supremacy of history painting. His
own allegiance to this viewpoint is demonstrated in early
work in the grand style such as 'The Tenth Plague of
Egypt' (BJ 17; Reserve Gallery 1) and 'The Deluge' (BJ
55; Gallery 107), which at the same time announce his
aim of raising the status of landscape painting. This
figure group seems to show the climax of some incident
from an unidentified literary subject. The procedure of
making ink sketches on dark-toned paper shows an
awareness of the drawing techniques and draughtsman-
ship of Old Masters such as Rembrandt, whose work
was an important influence on Turner. The fluent
penwork evident here occurs in many of his 'Studies for
Pictures', but this sheet appears not to be related to any
finished composition.

20 **Study for a composition: 'Phryne'?** *c.* 1804–10
Pen and black ink
138 × 300 ($5\frac{7}{10}$ × 11$\frac{13}{16}$)
Turner Bequest; CXX M
D08227

Like cat. no. 19, this sketch is an example of the sort of
preparatory stage through which many of Turner's
more complicated figure subjects passed. It has been
suggested that this study shows a projected composition
based on the story of Phryne, a celebrated Greek
courtesan on the fourth century BC. Turner was to
exhibit a picture of this theme many years later, in
1838 ('Phryne going to the Public Baths as Venus –
Demosthenes taunted by Æschines', BJ 373, Reserve
Gallery 3).

21 **Interior of a French Church with
Figures*** *c.* 1830
Pencil, pen and ink with bodycolour and
watercolour on blue paper
190 × 145 ($7\frac{1}{2}$ × 5$\frac{11}{16}$)
Turner Bequest; CCLIX 252
D24817

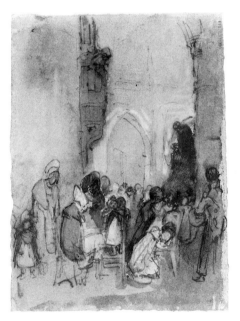

Turner's commitment to the figure element in his
paintings and watercolours continued throughout the
period from 1800 to the later 1830s, and was most
notably expressed in the series of engravings which he
published as the *Liber Studiorum* (see cat. nos. 27, 28, 29,
33, 34 and 42). By the mid 1820s he had been involved
in a number of engraving projects including the group
of *Picturesque Views on the Southern Coast of England*
(cat. no. 35) which foreshadowed the *Picturesque Views in
England and Wales* series of 1825–35 (see cat. nos. 31, 37
and 53). Encouraged, no doubt, by the increasing
popularity of topographical engravings of Continental
subjects since the end of the War, he embarked on an
ambitious project which aimed to cover the 'Great
Rivers of Europe'. Three annual volumes appeared,
focusing on the Rivers Loire and Seine, for which he
made many preparatory sketches on blue paper. This
scene comes from that group of drawings but it is
unlikely that Turner intended to use it as the basis for an
engraving. It shows the interior of one of the great
churches or cathedrals of Northern France. The hastily
sketched figures are given rather more prominence than
the architecture and, as in the sketch of a fish market
(cat. no. 30), Turner is concerned to capture the essence
of daily life as he witnessed it.

22 **Funeral of Sir Thomas Lawrence: a Sketch from Memory***
Exhibited RA 1830
Watercolour and bodycolour
616 × 825 (24¼ × 32½)
Turner Bequest; CCLXIII 344
D25467
W.521

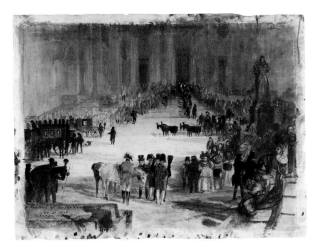

Although Turner's art was flourishing during the 1820s, this was a time of personal crisis caused by the deaths of many of the people close to him, including his friend and patron Walter Fawkes, and, shortly afterwards, his own father. In 1830 came the death of another friend, Sir Thomas Lawrence, President of the Royal Academy. This picture, showing the funeral procession arriving at the steps of St Paul's Cathedral, was unprecedented among Turner's Royal Academy submissions. It represents a personal act of homage to the old President. The event constituted something of the ending of an epoch and Turner was once again reminded of the possible imminence of his own demise. On 22 January, the day after the funeral, he wrote of these fears to the artist George Jones, while commenting that 'it is something to feel that gifted talent can be acknowledged by the many who yesterday waded up to their knees in snow and muck to see the funeral pomp'. As in the watercolours of the Pantheon and the burning of the Houses of Parliament (cat.nos. 13 and 24), Turner here depicts the crowds at a public event – this time one of shared grief – with the figures again recreated 'from memory' rather than being sketched on the spot.

23 **Going to School** *c.* 1832
Pencil and watercolour
269 × 219 (10 9/16 × 8 5/8)
Turner Bequest; CCLXXX 198
D27715

When involved in engraving projects, such as the 'Rivers of Europe', or the *Picturesque Views in England and Wales*, Turner would make a large number of drawings from which the publisher could select those he thought most suitable. This was certainly true of the two publications undertaken to accompany the work of the poet Samuel Rogers: 'Italy', 1830; and 'Poems', 1834. This watercolour was intended for the 'Poems', but was in fact not chosen for publication. Like 'The Old Oak' (cat. no. 56) its subject is the minutiae of human life. Here, in a study reminiscent of the genre scenes of painters like William Mulready, Turner provides a Shakespearean sketch of an unwilling schoolboy, every line of the figure conveying his reluctance.

24 The Burning of the Houses of Parliament 1834

Watercolour and bodycolour
302×444 ($11\frac{7}{8} \times 17\frac{1}{2}$)
Turner Bequest; CCCLXIV 373
D36235
W. 522

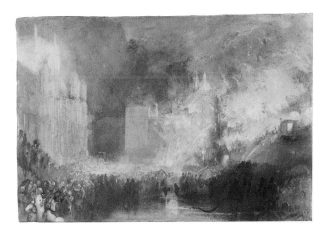

Turner was one of the thousands of eye-witnesses of the fire which burnt down the old Houses of Parliament in October 1834. A report in the diary of a Royal Academy student records that Turner arrived early at the scene, and afterwards made a series of rapid watercolour sketches inspired by the experience (TB CCLXXXIII). Turner's oil paintings of the subject (BJ 359 and 364), appeared at the British Institution and the Royal Academy the following year; and Turner also made this more elaborate watercolour which may have been intended to be engraved as a report of the fire. Although unfinished, it is much more descriptive than the studies (which in fact do not seem to relate in any specific detail to the event itself), in its account of the throngs of spectators who gathered to see the blaze.

25 High Street, Oxford* 1830–5

Pencil and watercolour
382×558 ($15\frac{1}{16} \times 21\frac{15}{16}$)
Turner Bequest; CCLXIII 362
D25485

This sheet appears to be a study for a subject intended for inclusion in the series of *Picturesque Views in England and Wales*. Though no finished view was executed, there are three other watercolour sketches of the same composition, which are all developments of a pencil sketch in the *Kenilworth* sketchbook (TB CCXXXVIII f. 1 verso), made during Turner's tour of the Midlands in 1830. They take up a subject approached earlier in his career in the oil painting of Oxford High Street which had been engraved in 1812 (see fig. no. 2).

Although unfinished, the drawing shows the artist's working method and highlights the role given to the figure. The crowds on the left, the stage coach approaching in the middle distance and the group of women and children in the foreground are all strongly suggestive of the range of human activity appropriate to the subject.

26 **Bellinzona from the North: A**
 Procession 1842
 Pencil and watercolour with some pen
 230 × 288 ($19\frac{1}{16} × 11\frac{5}{16}$)
 Turner Bequest CCCLXIV 343
 D36203

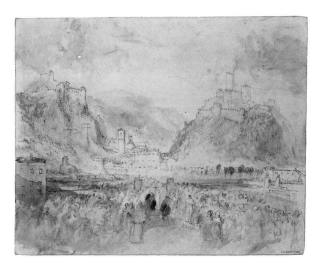

Although Turner never altogether ceased to make close observations of the figure (see for instance the *Rotterdam to Venice* sketchbook, cat. no. 78), much of his later work shows an apparent neglect of the individual components of the crowds he depicts. In this watercolour the crowd appears to be involved in a religious procession, with some of the figures bearing banners. Turner had noted a similar procession on a much earlier visit to Switzerland, perhaps at Martigny, in the *Swiss Figures* sketchbook of 1802 (cat. no. 70).

The Labours of Man: by Land

27 **Hedging and Ditching** *c.* 1808
 Brown wash with pen and ink
 185 × 258 ($7\frac{5}{16} × 10\frac{5}{16}$)
 Turner Bequest; CXVII W
 D08151
 Engraved by C. Easling for the *Liber Studiorum*
 (plate 47), published 1809

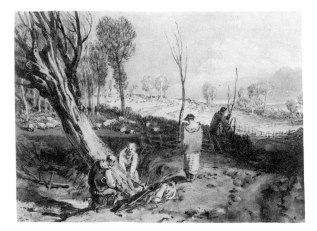

This design for the *Liber Studiorum* was based on a swift sketch made on a journey from Portsmouth to London in 1807 (TB C f. 47). The eighteenth century witnessed a fundamental change in the nature of agricultural life in Britain. One element was the trend towards enclosure, with its rationalisation of the previously open field system of farming, bringing into arable cultivation land hitherto unemployed. The face of the landscape was radically altered by enclosure and it is this process of change which Turner shows here, with labourers engaged in fencing, hedging and the construction of new drainage systems. Ruskin regarded this design as ugly in its portrayal of 'meanly faced, sickly pollard labourers' (*Works*, vol. VII, p. 433); however, Turner obviously had no intention of sentimentalising the lot of the rural labourer. More sympathetic than Ruskin, the Rev. Stopford Brooke wrote in his *Notes on the Liber Studiorum*, 'Rough and coarse as the figures are, they are not vulgar. They are of the earth, and have the dignity of the earth' (p. 159).

28 **Kingston Bank** *c.* 1810
 Brown wash with pen and ink
 198 × 268 ($7\frac{13}{16}$ × $10\frac{9}{16}$)
 Turner Bequest; CXVIII W
 D08177

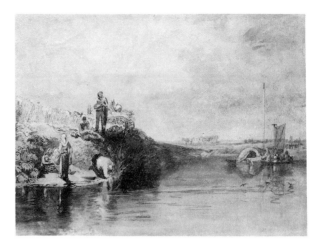

This is another study for a plate in the *Liber Studiorum* although the design was never published. The subject is based on the painting 'Harvest Dinner, Kingston Bank', which Turner exhibited in 1809 (BJ 90, Reserve Gallery 1). It has been seen as a depiction of women delivering lunch to the harvesters; however, it seems possible that they have arrived to glean after the harvest has taken place. The figure of the woman with her back to us appears to have 'gleaning pockets' at her sides; these were large holders in which to place the corn. Work has stopped for the group in the foreground, although the loading of straw onto the cart and the transporting of the crop still continues in the background. The heat of the day is suggested by the man crouching on the river bank to wash his face. Turner no doubt frequently saw such scenes while making his sketches along the Thames in the first decade of the nineteenth century (see TB XCV).

29 **The Peat Bog** *c.* 1810
 Brown wash with pen and ink
 188 × 268 ($7\frac{3}{8}$ × $10\frac{9}{16}$)
 Turner Bequest; CXVII T
 D08148
 Engraved by G. Clint for the *Liber Studiorum* (plate 45), published 1812

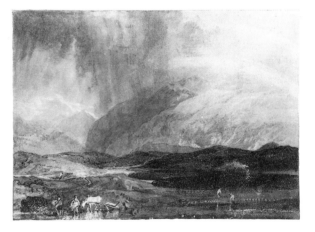

Turner's understanding of the harshness of many aspects of rural life finds perhaps its fullest expression in this work, a study for a plate in the *Liber Studiorum*, in its depiction of 'cold, dark rain, and dangerous labour' (Ruskin, *Works*, vol. VII, p. 433).

 Peat was and, to an extent, still is dug over most of Scotland as a source of fuel. In Turner's time it was cut not only for the crofter himself, but also for the landlord as a contribution to the tenant farmer's rent. Cutting peat began in late April and was primarily the task of men, with the women and children laying the turfs out to dry. The calculation that an average family would need to cut around 15,000 peats in a year, and that it would take a good worker to cut maybe 1000 a day, indicates the importance of the task and the time that had to be devoted to it.

 Turner's awareness of the everyday lives of the Scottish people would have been developed during his travels in Scotland in 1801, which are documented extensively in a series of sketchbooks and watercolours.

This knowledge has been used to create a design which indicates the rapidly changing weather, the treacherous landscape and the labours of the peat cutters. A sense of the sublime is created by both the dramatic landscape and the inclusion of the peat-cutters as small, somewhat pathetic figures. This does not signify their lack of importance in the composition; on the contrary, it expresses their vulnerable position in a bleak and hostile environment.

30 **A Fish Market, Calais** *c.* 1826
Pencil, pen and brown ink with some white bodycolour, on blue paper
138 × 191 ($5\frac{7}{16} × 7\frac{1}{2}$)
Turner Bequest; CCLX 46
D24882

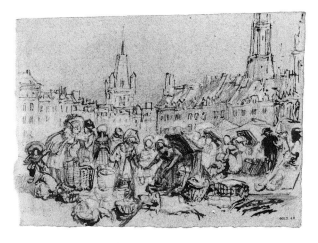

It has been suggested that this pen and ink sketch may have been prepared in connection with an unrealised project for a series of engraved views of the channel and its hinterland, to be known as 'La Manche' (see cat. no. 38)

Turner's interest in local dress and customs are apparent once again in the clear description of the gathering and all the impedimenta usually associated with a bustling market-place. The trader in the centre appears to be weighing fish from the baskets while part of the catch is laid out around the stall.

31 **Louth, Lincolnshire** *c.* 1827
Exhibited 1829
Watercolour with scraping-out
285 × 420 ($11\frac{3}{16} × 16\frac{9}{16}$)
Trustees of the British Museum, 1910-2-12-278
Engraved by W. Radclyffe, 1829, for the *Picturesque Views in England and Wales* (R. 233)
W. 809

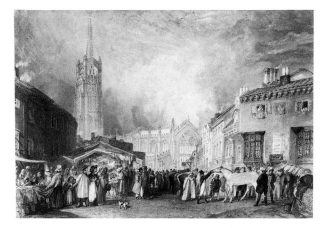

A pencil study of the architecture in this subject appears in the *North of England* sketchbook (TB XXXIV f. 80) of 1797, although, as was often Turner's practice, the human activity in the foreground was only added when the scene was worked up into a finished watercolour.

Ruskin found the subject-matter of this drawing objectionable, maintaining that the earthy and entertaining figures had been included (against Turner's higher moral instincts) merely to please a mass audience. But, as Rawlinson points out, 'homely subjects were by no means uncongenial to him [Turner] ... he would probably have thoroughly enjoyed the sights and sounds of a country fair'. The very detail of this lively watercolour bears witness to this fact. Indeed markets and country fairs are frequently noted in his sketch-

books both in England and on the Continent, and such
scenes were often incorporated into his finished works.
His obvious delight in social and economic relationships
is apparent in the depiction of the horse-traders who
contrast noticeably both in dress and manner to the
inquisitive townsfolk and country people who have
gathered to see the spectacle.

32 **Beaugency** *c.* 1830
 Bodycolour with pen and ink on blue paper
 138 × 188 ($5\frac{7}{16}$ × $7\frac{7}{16}$)
 Turner Bequest; CCLIX 95
 D24660

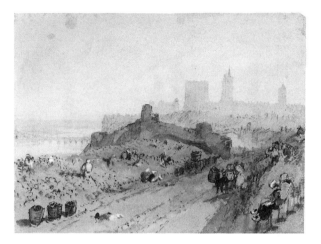

This study is based on a composition roughly sketched
in the *Loire*, *Tours*, *Orleans*, *Paris* sketchbook (TB
CCXLIX f. 25). Once again Turner concentrates not so
much on the bald facts of the townscape, but on the life
of the inhabitants who work along the roadside. Details
of local costume and the transport of produce are all
noted in the same sketchbook.

This drawing is one of a series of watercolours
executed for possible inclusion in the Loire project of
c. 1826–30, although it was a different view of Beau-
gency (W. 932) which was finally engraved as part of
Turner's Annual Tour – The Loire in 1833 (R. 432–452).

The Labours of Man: by Sea

33 **Flint Castle** 1806–10
 Brown wash with pen and ink
 327 × 413 ($12\frac{7}{8}$ × $16\frac{1}{4}$)
 Turner Bequest; CXVI C
 D08104
 Engraved by C. Turner for the *Liber Studiorum*
 (plate 4)

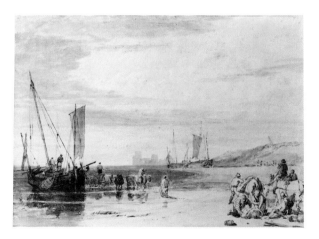

In this design the ruined castle in the distance is a foil to
Turner's main interest, the human activity in the
foreground where a boat's cargo is being offloaded into
carts and sorted on the shore. Despite Ruskin's sugges-
tion that the men are smugglers, there seems to be no
definite pictorial evidence to support this idea.

Turner reinterpreted the subject matter of this design
in two watercolours of the 1830s, one of them engraved
for the series of *Picturesque Views in England and Wales*,
(W. 868 and W. 885).

34 **Marine Dabblers** 1806–10
Brown wash with pen and ink
176 × 260 (6$\frac{15}{16}$ × 10$\frac{1}{4}$)
Turner Bequest; CXVII F
D08133
Engraved by W. Say for the *Liber Studiorum* (plate
29), published 1811.

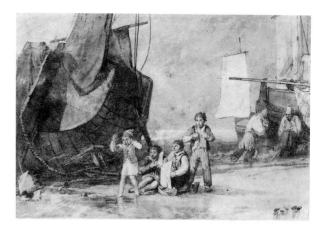

This view was described by Rawlinson as both comic in
its handling and commonplace in its subject (*Turner's
Liber Studiorum*, pp. 50 and 58). Ruskin was the first to
note its true implications, admitting that although
Turner may not draw children as well as, for instance,
William Mulready, the depth of feeling is greater: 'Just
glean out of his works the evidence of his sympathy with
children' (*Works*, vol. IV, p. 26). This view is amplified by
the Rev. Stopford Brooke: 'The labourers with whom
Turner had most sympathy … were those who toiled
upon the sea'. The boys are wholly occupied in their
amusement, 'playing at the business they will after-
wards pursue, and Turner's grim sense of the danger
and trouble of their kind of life … is shown in the
shipwreck of the toy boat'.

The theme of children at play with boats often recurs
in Turner's work; most notably in the foreground of the
oil painting 'Dido building Carthage' (BJ 131); and in
pencil sketches in the *Brighton and Arundel* sketchbook
(TB CCXLVI ff. 11 verso, 12) of *c*.1830 and the *Marine
Dabblers* sketchbook (TB CCXLI ff. 38 verso, 39 and 46
verso) of *c*.1829–30.

35 after J. M. W. Turner
St Mawes, Pilchard fishing
Engraver's proof
143 × 219 (5$\frac{5}{8}$ × 8$\frac{5}{8}$)
T05420
Engraved by J. C. Allen, 1824, for the *Picturesque
Views on the Southern Coast of England*, (R. 116)

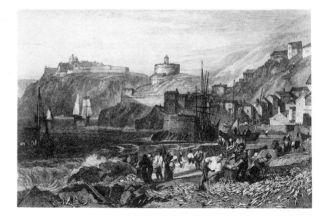

Turner visited St Mawes in 1811 while gathering
material for W. B. Cooke's *Picturesque Views on the
Southern Coast of England*, this being one of four views of
the town (see also BJ 123, W. 762 and W. 823). This
particular engraving is based on the watercolour
(W. 473) in the Yale Center for British Art. Here, the
town is dominated by its castle, built as part of Henry
VIII's defences against the French. However, rather
than concentrating on historical and topographical
features, Turner has paid greater attention to the
activity in the foreground. While this emphasis is
apparent in all four versions of the scene (see 'St Mawes
at the Pilchard Season', Gallery 108), this particular
view illustrates most vividly the depressed state of the
fishing industry. Export opportunities for the fishermen

had diminished during the Napoleonic Wars and the subsequent Continental blockades. This slump meant that the only use for the unwanted fish was to sell them off locally as manure.

Instead of the careful sorting and storage of fish, which occurs in the other St Mawes works, Turner shows pilchards being shovelled onto the beach in the middle distance.

36 **Fisherwoman on the Sands** *c.* 1826
 Chalk and bodycolour
 134 × 192 ($5\frac{1}{4}$ × $7\frac{9}{16}$)
 Turner Bequest; CCLX 102
 D24938

The theme of a fisherwoman digging for bait is explored several times by Turner, in watercolour sketches (see TB CCLX 44, and TB CCLIX 214), in pencil studies (TB CCXVI f. 227) and, at its most fully developed, in the oil 'Calais Sands, Low Water, Poissards collecting Bait' (BJ 334).

The stooping woman may seem ungainly, yet she evokes a sense of the effort required by her task, as do the weary labourers in *Hedging and Ditching*, (see cat. no. 27).

37 **Lancaster Sands** *c.* 1826
 Watercolour
 278 × 404 ($10\frac{13}{16}$ × $15\frac{7}{8}$)
 Trustees of the British Museum, 1910-2-12-279
 Engraved by R. Brandard, 1828, for the *Picturesque Views in England and Wales* (R. 227)
 W. 803

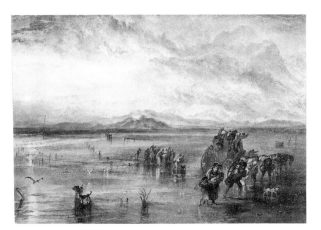

In this watercolour Turner dramatises the dangers facing the traveller in a group of men, women and children struggling to cross Lancaster Sands (which forms part of Morecambe Bay in Lancashire). It was necessary to be led across by guides who were familiar with the quicksands and tide patterns. Ruskin refers to this work as a poetic representation of the sea reclaiming its territory. The idea is epitomised in the seagulls who chase the dogs away from the water's edge just as the advancing tide laps at the travellers' feet.

38 **Waiting near the Pier, Brighton** *c.* 1827-8
Watercolour and bodycolour
138 × 191 ($5\frac{3}{8}$ × $7\frac{1}{2}$)
Turner Bequest; CCLIX 271
D24836

This study of crowds on the seafront at Brighton may be connected with the engraving project (which was never realised), 'THE ENGLISH CHANNEL, or LA MANCHE, to consist of views taken by him [Turner] from Dunkirk to Ushant, and places adjacent; together with others, on the opposite shore of England'. The use of bodycolour on blue paper is reminiscent of similar studies in the Petworth and 'French Rivers' series.

In the background can be seen the outline of Brighton's Old Chain Pier, a subject Turner depicted in two paintings, one of which is on display in Gallery 102 (BJ 286). After the erection of the Chain Pier, Brighton served as an embarkation point for journeys to the Continent.

39 **Folkestone from the Sea*** *c.* 1832
Watercolour with some bodycolour
488 × 684 ($19\frac{3}{16}$ × $26\frac{15}{16}$)
Turner Bequest; CCVIII Y
D18158
W. 512

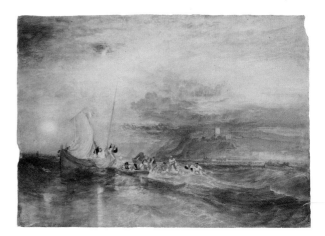

It is not known for what purpose Turner executed this splendid drawing, which was never engraved and is not as highly finished as most of his contemporary water-colours, for instance those he made for the *Picturesque Views in England and Wales*. A related watercolour known as 'Twilight – Smugglers off Folkestone fishing up smuggled gin' (W. 509), suggests that this shows a similar escapade. Smuggling was a matter of immediate concern to Turner's contemporaries, a well established feature of the economy against which numerous legisla-tive moves had been taken. In 1822, customs rates accounted for sixty-four per cent of the market value of net imports; any hindrance to smuggling would there-fore be of great financial benefit to the government. The specific smuggling methods depicted here have been explained as those of 'sinking and creeping', the goods being heavily weighted and sunk, the smugglers return-ing later under the pretence of fishing to 'creep' the kegs by dragging the sea bed with hooks and hauling aboard their contraband. The watercolour shows the arrival of the excise men and the smugglers hurriedly disposing of their 'catch'.

The Labours of Man: in Field and City, at Forge and Furnace

40 **Interior of an Iron Foundry** * *c.* 1797
Watercolour
247×345 $\left(9\frac{11}{16} \times 13\frac{9}{16}\right)$
Turner Bequest; XXXIII B
D00873

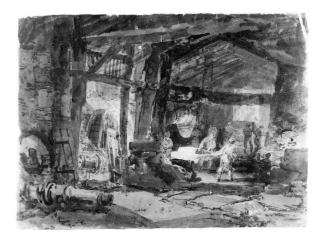

This early watercolour shows workers in an iron foundry; the striking heat of the fires and the molten metal are vividly suggested. It is based on a pencil study in the *North of England* sketchbook (TB XXXIV f. 90). Turner's interest in such a subject may have been prompted by a commission from a Welsh ironmaster to make drawings of his works near Merthyr Tydfil during the Welsh tour of this year.

By the late eighteenth century the iron industry was the expanding heart of the Industrial Revolution. Turner was one of a large number of artists inspired by the pictorial possibilities of industry.

41 **Workmen lunching in a Gravel Pit** * *c.* 1797
Pencil and watercolour
434×373 $\left(17\frac{1}{8} \times 14\frac{11}{16}\right)$
Turner Bequest; XXXIII E
D00876

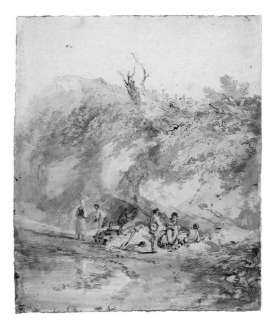

The period 1792–1800 saw a dramatic rise in the number and type of genre paintings exhibited at the Royal Academy. Traditional subjects taken from rustic life, such as haymaking began to be mixed with less romantic images, such as lime-burning and carting sand; these followed a new fashion for the low-life realism of the seventeenth century Dutch Masters.

42 **Morpeth, Northumberland** 1806–8
Brown wash with pen and ink
186 × 260 ($7\frac{5}{16}$ × $10\frac{1}{4}$)
Turner Bequest; CXVI Y
D08126
Engraved by C. Turner for the *Liber Studiorum*
(plate 21), published 1809

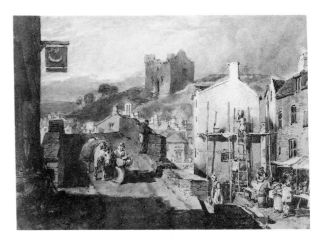

In this study for the *Liber Studiorum*, Turner is once again illustrating the diverse activities of a market town, with its market stalls, builders at work and people going about their daily routine.

A pencil sketch for this subject appears in the *Helmsley* sketchbook (TB LIII ff. 31 verso, 32), and includes indications of the men who are working on the house in the foreground.

43 after J. M. W. Turner
Leeds 1823
Lithograph
301 × 437 ($11\frac{13}{16}$ × $17\frac{3}{16}$)
Trustees of the British Museum, 1878-5-11-455
Engraved by J. D. Harding (R. 833)

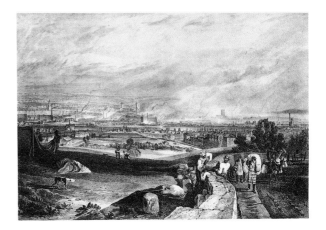

A panoramic sketch of Leeds, on which this watercolour is based, appears in a sketchbook (TB CXXXIV ff. 79 verso, 80 and 38) though it contains no notes of human activity.

Details of the figures, their dress and occupations, occur in other sketches (TB CXXXIV ff. 37 verso, 38 verso and 45). They illustrate the different stages of cloth manufacture which Turner could have observed on his visits to his patron Walter Fawkes at Farnley Hall near Leeds.

In the foreground, two tentermen are hanging a newly washed cloth out to dry and a clothworker is approaching with a further bale. In the central area of the scene, two masons are repairing a drystone wall, while on the hill milk carriers and others are going about their daily business.

It has been suggested that perhaps Turner used George Walker's *The Costume of Yorkshire* to amplify his own observations of the locality; four of the figures introduced into the subject are possibly derived from illustrations in that work.

44 **Shields on the River Tyne** 1823
　　Watercolour
　　154 × 215 $(6\frac{1}{16} × 8\frac{7}{16})$
　　Turner Bequest; CCVIII V
　　D18155
　　Engraved by C. Turner, 1823, for the *Rivers of
　　England*, (R. 752)
　　W. 732

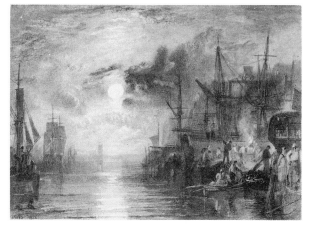

Both in its subject-matter and in its unexpectedly
Claudian composition this picture relates directly to an
oil painting in the National Gallery of Art, in Washing-
ton, 'Keelmen heaving Coals by Night' (BJ 360). Both
are reflections upon Britain's mercantile and industrial
prowess.

　　As in another of Turner's industrial subjects, 'Dud-
ley' (W. 858), a moonlit nocturne allows dramatic
contrasts between the cool peaceful sky and the heat
and bustle of the scene below. On the right keelmen are
unloading coal from the 'keels' (flat-bottomed boats)
which were used to transport coals down from the fields
above Newcastle: water transport was both faster and
cheaper than carriage by road.

45 **Kirkstall Lock** * 1824–5
　　Watercolour
　　159 × 235 $(6\frac{1}{4} × 9\frac{1}{4})$
　　Turner Bequest; CCVIII L
　　D18145
　　Engraved by W. Say, 1827, for the *Rivers of
　　England*, (R. 765)
　　W. 745

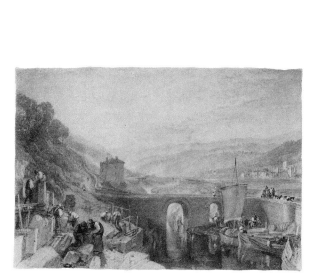

Studies for this design are to be found in two sketch-
books: TB CVII and TB CCX f. 60 verso. Although it is
nominally a 'Picturesque View' on the River Aire, this
watercolour summarises with characteristic compre-
hensiveness the social and economic history of the spot.

　　In the middle distance, Kirkstall Abbey is a reminder
of its medieval importance, while the foreground activ-
ity illustrates the development of this part of outer Leeds
since 1700. The River Aire had been made navigable in
1699, and construction of the Leeds to Liverpool canal,
seen in the foreground, had provided access to the port
and so to overseas markets since the 1770s.

　　In the left foreground, workmen are engaged in the
building of a brewery. Turner may well have seen this
activity during his visit to the area in 1797. The site had
been developed after its lease to a local maltster in 1793
and the work was complete by 1811 when it appeared
on a plan of the locality. It has been suggested that
Turner's memory of a stone quarry on this site,
combined with a recollection of the construction of the
brewery, may have prompted his design.

46 **Harfleur** *c.* 1832
Watercolour and bodycolour
140 × 192 $(5\frac{1}{2} × 7\frac{9}{16})$
Turner Bequest; CCLIX 196
D24761

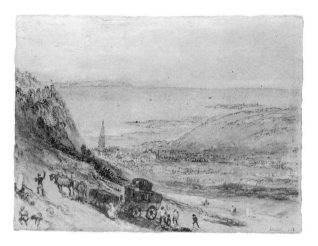

During Turner's lifetime the nature of travel in Europe changed dramatically. In the mid-eighteenth century roads were for the most part unadopted and treacherous, while transport by sea was often slow and precarious. With the rapid improvement of road surfacing towards the end of the century and the advent of steam the transport system became more regular and reliable.

Turner spent a large part of his life travelling, both at home and abroad, and so was a frequent victim of the inconveniences that befell the traveller. The incidents that occurred in the course of these journeys obviously had a marked effect on him; he depicted two road accidents in which he was involved: 'Snowstorm, Mont Cenis' (w.402), when the carriage in which he was travelling overturned in a snowdrift, and an incident of nine years later 'Messieurs les voyageurs on their return from Italy (par la diligence) in a snow drift upon Mount Tarrar – 22nd January 1829' (w.405).

This watercolour depicts a coach and horses struggling to reach the top of the hill above the town. The travellers have left the coach and are walking behind; their climb is depicted with lively attention to detail, the woman hitching up her skirts, the old man trailing behind and the young child being led.

47 **Between Mantes and Vernon** * *c.* 1832
Watercolour and bodycolour
143 × 194 $(5\frac{5}{8} × 7\frac{5}{8})$
Turner Bequest; CCLIX 114
D24679
Engraved by R. Brandard for *Turner's Annual Tour – The Seine*, 1835 (R. 477)
W. 975

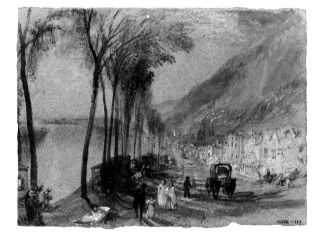

This scene depicts one of the pleasurable aspects of road travel in Turner's time. Beside a road running along the River Seine, tables are set out under the trees and refreshments await tired travellers on a hot summer's day. This is one of the 'posts' or stopping points on a busy main route from Paris outside Mantes, the number of coaches pulled up under the tree suggesting the quantity of traffic.

48 **Coblenz** 1840–1
243 × 343 ($9\frac{9}{16}$ × $13\frac{1}{2}$)
Watercolour, bodycolour and coloured chalk
Turner Bequest; CCCLXIV 284
D36137

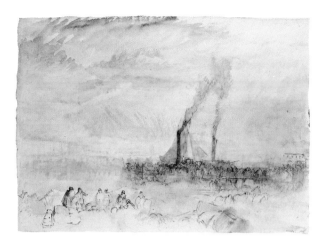

This study shows travellers with their luggage waiting to board the Rhine steamer; crowds have gathered at the pier on the right. Their hurried movements are evoked by rapid touches of the brush.

A frequent and compulsive traveller himself, Turner in the 1840s had particular cause to reflect on the dramatic improvements in travel by road and water in his lifetime. He treats the steam-boat in various contexts, sometimes referring nostalgically to the demise of the sailing ship with all its romantic associations; but in general, as in 'The First Steamer on the Lake of Lucerne' (W. 1482), and in his many drawings of steamers on the Seine, his view of these developments is an optimistic one.

High Days and Holidays

49 **Newcastle-on-Tyne** *c.* 1823
Pencil and watercolour
152 × 215 (6 × $8\frac{7}{16}$)
Turner Bequest; CCVIII K
D18144
Engraved by T. Lupton, 1823, for the *Rivers of England*, (R. 753)
W. 733

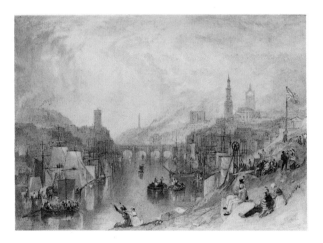

This watercolour is worked up from a study in the *Scotch Antiquities* sketchbook (TB CLXVII f. 2), drawn when Turner passed through Newcastle on his way north in 1818.

It presents a cross-section of the town's population; on the bank in the foreground are two young girls, a soldier and a sailor with his companion, while on the river below keelmen are transporting coals from the moored colliers. While the picture evokes both relaxation and leisure it also emphasis Newcastle's role as an industrial centre (see also cat. no. 44): the city's notable churches and its cathedral are visible in the distance amid the smoke. The intimate and familiar are blended in an almost theatrical vision typical of Turner's city views. A later, but parallel, treatment of the theme is cat. no. 57.

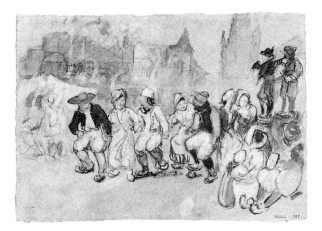

50 **French Peasants dancing** * 1826–30
Watercolour and bodycolour
132 × 190 $(5\frac{3}{16} × 7\frac{1}{2})$
Turner Bequest; CCLIX 197
D24762

It has been suggested that Turner observed this scene of townspeople dancing in clogs to the music of the fiddler and the drummer while he was touring Brittany in 1829, in search of material for his project to illustrate Channel scenery. Like many studies made in France at about this time it departs from the topographical brief by recording figures in some detail and as the principal subject of the composition. While fairly elaborate, this particular work was evidently never intended to be engraved.

51 **Shore Scene at Ambleteuse** *c.* 1826–30
Pen and ink, with bodycolour, on blue paper
142 × 191 $(5\frac{9}{16} × 7\frac{1}{2})$
Turner Bequest; CCLX 53
D24889

Turner's lively sense of humour delighted in the comic situations in which humanity so often finds itself: children at play, in particular, attracted him and he often noted their games and quarrels in works like 'Juvenile Tricks', published in the *Liber Studiorum* (plate 22), or the late painting he titled 'The New Moon; or "I've lost My Boat, You shan't have Your Hoop"' (BJ 386; Gallery 101). The *Channel* sketchbook contains a memorandum of 'Boys playing at leap frog – Girls jumping over Sand Humps' (Yale Center for British Art).

This pen and ink study, possibly a design made in conjunction with the proposed engravings of 'The Channel or La Manche', shows two children balanced astride a small donkey, in a scene on the coast of northern France.

52 **A Group of Figures, perhaps at Brighton** *c*.1826–30

Black chalk, pen and ink with some watercolour on blue paper

135 × 194 ($5\frac{5}{16} \times 7\frac{5}{8}$)

Turner Bequest; CCLX 99

D24935

This drawing may have been made at Brighton while Turner was preoccupied with the 'La Manche' project (see cat. no. 38). Like cat. no. 53, it deals with the leisure activities of people at the seaside. Here a group of elegant figures are seen promenading on the sea-front, or perhaps on the Old Steine, recalling Constable's complaint of a few years earlier that 'Brighton is the receptacle of the fashion and offscouring of London ... the beach is only Piccadilly ... by the Sea-side'. Indeed Brighton, like many coastal resorts, became a focus of rapid expansion in these years, largely because of its closeness to London and the fashion for sea-bathing. Turner was to witness a similar transformation at his favourite retreat of Margate during the 1830s.

53 **Plymouth**

Exhibited 1829

Watercolour with scraping-out

280 × 412 ($11 \times 16\frac{1}{4}$)

Engraved by W. J. Cooke, 1832, for the *Picturesque Views in England and Wales* (R. 259)

The Board of Trustees of the Victoria and Albert Museum, 521–1882

W. 835

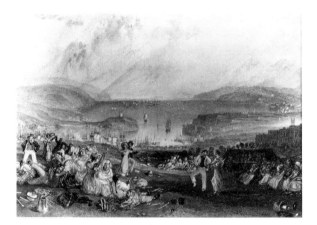

Turner's sketches of this view give no indication of the animated crowds with which he was to fill the finished watercolour. The panorama is taken from above Sutton Pool, with Mount Batten Point to the left, and is based on an amalgamation of pencil sketches in the *Ivy Bridge to Penzance* and the *Plymouth, Hamoaze* sketchbooks (TB CXXV ff. 9, 10, 11, 12 and TB CXXXI f. 90).

Like the watercolours of 'Louth' and 'Lancaster Sands' (cat. nos. 31 and 37), this subject was engraved as part of the series of *Picturesque Views in England and Wales*. In 'Plymouth' Turner's allusion to the maritime history of the town (and by implication England's great naval tradition) in the forest of masts and sails in the harbour is amplified by the sailors' dancing and brawling. He also shows, with no trace of satire or condescension, the liberating effects of drink. In a scene flanked by a beer tankard and a bottle, the sailors and their women cavort with unselfconscious pleasure, or sprawl in drunken abandon. A similar scene of riotous nautical festivity occurs in another design for the series, 'Dartmouth Cove' (w. 787).

54 **Promenade at Nantes** *c.* 1830
Watercolour and bodycolour, with some pen, on
blue paper
126 × 183 ($4\frac{15}{16} × 7\frac{3}{16}$)
Turner Bequest; CCLIX 191
D24756

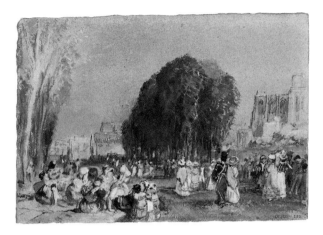

Turner's sketches for the 'French Rivers' include a large
number that record people engaged in their work,
making, selling and transporting their produce. Here he
shows another aspect of French life – the promenade.
The location is Nantes on the River Loire, which
Turner visited in 1826. Among the crowd of figures
strolling along the avenue leading towards the Château
are several soldiers. They recur in two closer views of the
Château (w. 950 and TB CCLIX 200). The presence of
the armed forces in contemporary France is reflected
throughout the 'French Rivers' drawings; the country
was in a turbulent state in these years, and indeed the
outbreak of the Siege of Paris in 1830 meant that
Turner was prevented from travelling there that year.
In both sketches and finished designs troops can often be
seen marching ant-like through steep river valleys or
along the quays of Paris, Rouen or Orleans.

55 **The Lake of Geneva** *c.* 1827
Pencil and watercolour
215 × 146 ($8\frac{7}{16} × 5\frac{3}{4}$)
Turner Bequest; CCLXXX 152
D27669
Engraved by E. Goodall, 1829, for Rogers's *Italy*,
1830 (R. 348)
w. 1152

This charming vignette, an illustration to Rogers's *Italy*,
features one of Turner's favourite subjects. Boating
parties appear in many of his views; for example in
'Jumièges' (w. 961, TB CCLIX 131), in the series of
'French Rivers' subjects, and in 'Saltash' (w. 794) from
the *Picturesque Views in England and Wales*. Here the artist
enjoys particularly the details of the soldiers' uniforms
and the costumes worn by the ladies of the group,
drawing all of them with his usual attention to detail.

56 **An old Oak** *c.* 1832
Pencil and watercolour
110 × 133 (4$\frac{5}{16}$ × 5$\frac{1}{4}$)
Turner Bequest; CCLXXX 174
D27691
Engraved by E. Goodall for Rogers's *Poems*, 1834
(R. 391)
W. 1195

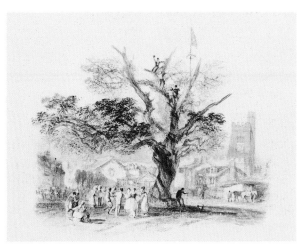

Rogers's poem 'To an Old Oak' for which this design is the head-piece, celebrates the long and eventful life of the tree, recalling the sights it would have witnessed. The conclusion of the poem is the tree's 'death' and its metamorphosis into a ship of the line (as illustrated in the vignette TB CCLXXX 175, W. 1196). Turner compresses into the miniature format of the book illustration a very complete and evocative statement of the atmosphere and customs of the countryside.

57 **Lausanne, Cathedral and Bridge** *c.* 1841
Pencil and watercolour
235 × 335 (9$\frac{1}{4}$ × 13$\frac{3}{16}$)
Turner Bequest; CCCXXXV 26
D33566

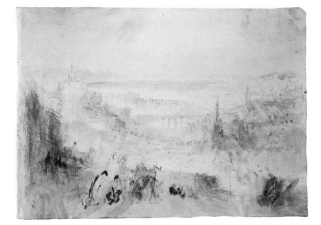

This image is strikingly similar in composition to the earlier view of *Newcastle-on-Tyne* (cat. no. 49), although the handling of the medium is very different. Its vibrant colours and the sketchy indications of the presence of people in the foreground are typical of the studies Turner made in the 1830s and '40s as preparations for finished compositions.

Figures in an Interior

58 **Music in the White Library, Petworth House** 1827
Watercolour and bodycolour on blue paper
140 × 190 (5$\frac{1}{2}$ × 7$\frac{1}{2}$)
Turner Bequest; CCXLIV 37
D22699

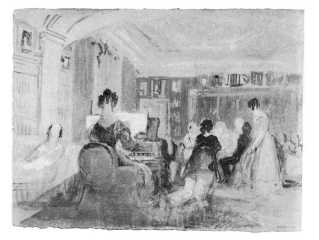

When Turner visited the third Earl of Egremont at Petworth House in 1827 he made a series of over a hundred studies on blue paper of which this is one. A large number of these drawings show the interior of the house and its occupants. Considering the secrecy with which Turner surrounded his working practice, often preferring to work up a pencil sketch in his hotel room or in his studio, the Petworth drawings are surprising in the consistent spontaneity he brought to them. Although the drawings are often summary, he skilfully

conveys the forms and even the personalities of the other guests, as well as their gestures. This view of the White Library shows the focal point of the house where the numerous guests would gather to meet their ageing host, who allowed other artists as well as Turner to use the house as a studio.

59 **The Billiard Players, Petworth House** 1827
Bodycolour and watercolour on blue paper
141 × 191 ($5\frac{1}{2}$ × $7\frac{1}{2}$)
Turner Bequest; CCXLIV 116
D22778

As well as enjoying the relaxed atmosphere at Petworth, the guests could take part in a number of sports from hunting in the parklands to fishing in the lake, a pastime Turner often indulged in. The Marble Hall, which was then still used as the formal entrance to the house, also served as a billiard room. Here Turner catches two figures engrossed in a game. A more developed study of sport at Petworth is to be found in the painting 'The Lake, Petworth: Sunset, Fighting Bucks' (BJ 288), which includes a cricket match taking place on the vast sweep of parklands in front of the house.

60 **Study of two Heads** *c.* 1827-35
Pencil on laid paper
159 × 201 ($6\frac{1}{4}$ × $7\frac{7}{8}$)
Turner Bequest; CCCXLIV 350
D34832

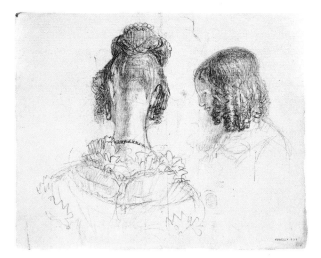

Many of the women in Turner's pictures are seen from behind, their hair swept up from their long necks. The feature is reminiscent of the women in the paintings and drawings of Henry Fuseli (1741-1825), with whose work Turner would have been familiar. This pencil study can be related to the painting 'Two Women with a Letter' (BJ 448; Reserve Gallery 3), as well as to the woman playing the piano in the drawing of the White Library at Petworth exhibited here (cat. no. 58). The pencil is employed with studied delicacy to depict the sort of elegant women who appear in the *fêtes champêtres* of Watteau. Turner had painted several pictures influenced by the French painter during the 1820s, while also admiring and competing in friendly rivalry with a painter he deemed the 'English Watteau', Thomas Stothard.

61 **Soldiers in a Tavern*** *c.* 1829

Watercolour and bodycolour with some pen on blue paper
140 × 190 ($5\frac{1}{2}$ × $7\frac{1}{2}$)
Turner Bequest; CCLIX 263 b
D40080

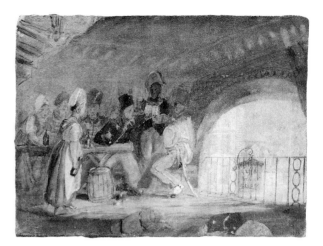

One can imagine Turner compulsively recording the details of this scene as he sat at an adjacent table in the tavern. Like other studies (cat. no 54; or TB CCLIX 132), it shows French troops off duty: the atmosphere of jovial camaraderie amongst the group is well caught, with the suggestion of banter between the soldiers and the serving-girl.

62 **The 'Al Fresco' Meal*** *c.*1830

Watercolour and bodycolour on blue paper
141 × 190 ($5\frac{1}{2}$ × $7\frac{1}{2}$)
Turner Bequest; CCLIX 28
D24593

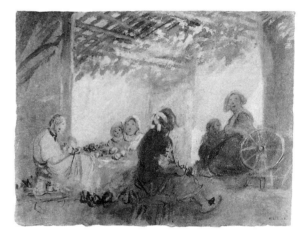

As well as recording scenes likely to prove useful in his work for the engravers, Turner made sketches which seem to have been executed simply for his own pleasure. Both this drawing and the tavern scene (cat. no. 61) are pervaded by a snap-shot quality in which he has sought to capture effects of light or to record people and events encountered during his travels. This group, in their shaded courtyard, seem to be interrupted in their meal by the presence of the artist – their features conveying both invitation and surprise. Along with other studies, this drawing testifies to an almost journalistic interest in the everyday details of contemporary French life.

63 **Interior with Woman and Child** *c.* 1832

Watercolour and bodycolour, with pen, on blue paper
138 × 194 ($5\frac{7}{16}$ × $7\frac{5}{8}$)
Turner Bequest; CCLIX 270
D24835

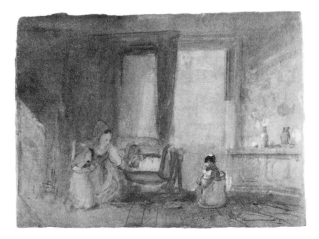

This intimate study of mother and child reflects a theme to be found occasionally in Turner's sketchbooks and illustrates Turner's interest in the most tender of human feelings. As in the Petworth drawings (see cat. nos. 58 and 59), he has utilised the colour of his paper to create the darkened effect of this interior.

64 **Interior of a French Cottage** *c.* 1832
Watercolour and bodycolour on blue paper
122 × 185 ($4\frac{13}{16}$ × $7\frac{1}{4}$)
Turner Bequest; CCLIX 190
D24755

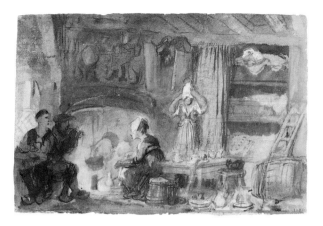

Turner's interest in depicting figures in interiors perhaps owed its revival in the later 1820s to the work of Richard Parkes Bonington (1802–1828). Bonington was based in Paris and it may be no coincidence that it was in France particularly that Turner came under his influence. This sketch shows the inhabitants of a cottage gathered round the fire about to commence a meal; it is related to a a pencil drawing in the *Paris and Environs* sketchbook (TB CCLVII 24 verso; *Turner en France*, p. 399 repr.), dating from Turner's 1832 French tour.

65 **Three Figures in a darkened Interior*** *c.* 1832
Bodycolour with traces of pencil and watercolour
on grey paper
131 × 227 ($5\frac{1}{8}$ × $8\frac{15}{16}$)
Turner Bequest; CCCLXIV 392
D36259

This study, perhaps connected with Petworth, provides another example of Turner's continuing interest in depicting figures in subdued indoor lighting (see cat. nos. 16 and 21). The figures are not so much actors in the scene, but rather forms over which Turner filters the firelight. The scene is charged with an erotic intimacy, made plain by the nude female figure seen at the right hand side. As with a handful of sketches in the main group of Petworth drawings and the *Colour Studies (1)* sketchbook (cat. no. 12), it is difficult to establish whether these studies are simply meditations on colour and light, or reconstructions of Turner's own exploits.

Sketchbooks

66 *Studies near Brighton* sketchbook 1796
A man and woman with children
Pencil with watercolour and bodycolour on blue
paper
108 × 128 ($4\frac{1}{4}$ × 5)
Turner Bequest; XXX f. 96 verso
D00842

This family group was perhaps noted at, or near, Brighton. The man carries what appears to be a bundle of wood while the woman has a basket. Travel is very much a theme of this sketchbook, with other compositions showing a carter looking after his wagon and

team (ff. 3 and 88 verso), and the passengers packed onto the open decks of a shipping vessel (f. 29).

67 *Wilson* sketchbook 1796-7
Interior of a forge
Watercolour with some bodycolour, pen and brown ink
114×92 $(4\frac{1}{2} \times 3\frac{5}{8})$
Turner Bequest; XXXVII pp. 102, 103
D01219, D01220

In this detailed study, Turner gives a clear account of industrial labour in this period. The glowing interior of the forge is contrasted with the light blue sky seen through the windows. The iron-workers are in the process of casting anchors, which suggests that the sketch was made near a shipyard or port. Other coastal scenes in this book indicate that its location may be Margate or perhaps Chatham.

68 *On a Lee Shore (2)* sketchbook 1800-1
Fishermen launching a boat in heavy seas
Pen and ink with brown wash
114×181 $(4\frac{1}{2} \times 7\frac{1}{8})$
Turner Bequest; LXVIII ff. 5 verso, 6
D03990, D03991

Turner's sympathy with those who work at sea is clearly demonstrated in the dramatic coastal scenes which fill this sketchbook. Here the potentially destructive power of the sea is indicated by a few summary lines contrasting with the detailed presentation of those who, as part of their everyday lives, battle against the unleashed forces of nature. Many of these studies were used for the painting 'Fishermen upon a Lee-Shore, in Squally Weather' (BJ 16), one of a number of meditations on the life of fishermen which he exhibited in the years around 1802.

69 *Helmsley* sketchbook 1801
A public fountain with seated figures and a horse drinking
Pencil
165×114 $(6\frac{1}{2} \times 4\frac{1}{2})$
Turner Bequest; LIII f. 95 verso
D02605

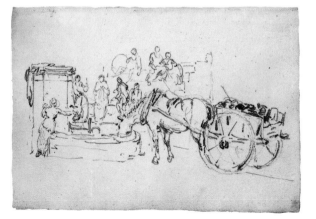

Documenting a tour of north-east England, this book contains detailed notes of the countryside and its inhabitants, and of their everyday life. Such observations would often contribute to finished watercolours years later; the sketchbooks were of continuing significance as a source of reference material. This sketch

depicts a period of respite during the working day, for men and animals alike. There are suggestions of children with hoops on the steps behind the fountain and the figures are in relaxed attitudes. The theme is continued on f. 11, where an old woman is drawn seated with a pot on her lap, apparently caught by the artist in mid-conversation.

70 *Swiss Figures* sketchbook 1802
Costume studies
Pencil and watercolour
197×159 $(7\frac{3}{4} \times 6\frac{1}{4})$
Turner Bequest; LXXVIII ff. 17, 18
D04814, D04816

This book, which accompanied Turner on his first tour of the Continent, shows in its numerous coloured figure studies his obvious delight in the contrasts with England that he noted abroad. Removed from their topographical surroundings, local people are observed for their own sake.

A suggestion of the context in which these sketches are to be placed appears on f. 10, which features a bargeman at work, and on f. 13, where a group of figures are drawn seated on and around a plough.

71 *Nelson* sketchbook 1805
Studies of naval costume
Pencil
107×178 $(4\frac{3}{16} \times 7)$
Turner Bequest; LXXXIX f. 15
D05463

Containing sketches relating to the Battle of Trafalgar and Nelson's battleship the 'Victory', this notebook is typical in its association of occupational characteristics and costume with specific contemporary events.

Here Turner has drawn five sailors, each with colour notes concerning his attire. Their jovial aspect is in contrast to the more formal pose and elaborate uniforms of the officers who are studied on f. 17.

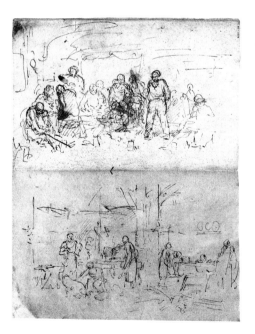

72 *Hesperides (1)* sketchbook 1805-7
Study for a figure subject; the interior of a blacksmith's shop
Pen and ink
167×266 $(6\frac{9}{16} \times 10\frac{7}{16})$
Turner Bequest; XCIII ff. 22 verso, 23
D05801, D05802

Turner used this sketchbook to work out a number of historical compositions on the theme of Dido and Æneas, but on this opening he has drawn from his own

experience. The upper sketch is possibly the interior of a tavern or some other place of relaxation, whilst the lower sketch relates directly to his first exhibited genre subject in the manner of the Dutch masters, 'A Country Blacksmith disputing upon the Price of Iron' 1807 (BJ 68; Gallery 108).

73 *River* sketchbook 1805–6
Field hands with scythes
Pencil
92 × 159 ($3\frac{5}{8}$ × $6\frac{1}{4}$)
Turner Bequest; XCVI f. 65 verso
D06050

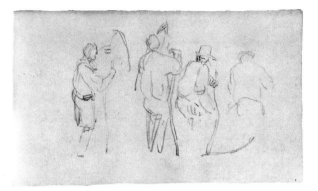

Pencil sketches of agricultural labour and the work of bargemen on the river make this sketchbook a fine record of Turner's interest in, and attention to, the details of contemporary working life. This sheet depicts different aspects of the task of reaping, from the sharpening of tools to the movement of the scythe in use.

74 *Itinerary Rhine Tour* sketchbook 1817
Figure studies
Pencil
57 × 113 ($2\frac{1}{4}$ × $4\frac{7}{16}$)
Turner Bequest; CLIX ff. 39 verso, 40
D12585, D12586

This tiny notebook documents Turner's 1817 tour of the Rhineland. Here he depicts the local costume and the uniforms of sailors and soldiers he encountered. As it was not Turner's habit to use watercolour while on tour, he made colour notes such as 'Col: Red Collar', 'W Pantaloons' to record his observations both rapidly and accurately.

He never lost sight of the fact that it was as a traveller that he saw Europe: this book includes transcriptions of passages from guide books to the area detailing notable landmarks and places of interest. He also noted on the inside front cover the German phrase, 'Vier ist myn Simmer' and its translation 'Where is my Chambre', one of his many, but apparently fairly fruitless, attempts to master foreign languages.

75 *Walmer Ferry* sketchbook *c.* 1817
A flirtation
Black ink and white chalk on laid brown paper
160 × 114 (6$\frac{5}{16}$ × 4$\frac{1}{2}$)
Turner Bequest; CXLII f. 16
D10669

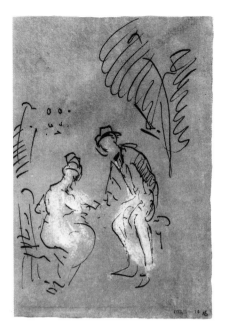

Most probably used around 1817, this sketchbook contains a number of studies of figures at work 'catching eels', as Turner notes on f. 10, or at ease, relaxing in woodland (f. 9 verso), on a river or lake (f. 97), or, as in this study, in conversation (see also f. 15). The air of flirtation in this subject is confirmed by a later pencil drawing in the *Life Academy (1)* sketchbook known as 'The Bivalve Courtship' (see cat. no. 11 and fig. 1), which bears a close similarity to the poses of this group. Turner uses pen and ink outlines to convey the form of the figures, with blurred highlights of chalk, in a way which anticipates his treatment of the figure in his drawings at East Cowes Castle and at Petworth House (see cat. nos. 58, 59).

76 *Gosport* sketchbook *c.* 1823–4
A group of figures with telescopes
Pencil
74 × 98 (2$\frac{7}{8}$ × 3$\frac{7}{8}$)
Turner Bequest; CCVII f. 33
D18052

Like sketchbooks used at the Cowes Regatta off the Isle of Wight in 1827, this book contains studies of both the shipping and the figures watching from the shore. Figures from the group seen here, with their telescopes, appear again on other pages (f. 36). As well as noting the games of children as they climb over an upturned boat (f. 44), Turner takes an interest in the details of women's costume, as attested in studies of them in their bonnets (f. 36 verso), and of their dresses blown by the wind (f. 19).

77 *Coutances and Mont St. Michel* sketchbook 1829
Studies of Normandy costumes; a church interior
Pencil
132 × 86 $(5\frac{3}{16} \times 3\frac{3}{8})$
Turner Bequest; CCL f. 22
D23375

The interior of the church sketched on the right-hand side of this page-opening is typical of this book, which details the spectacular surroundings at Mont St. Michel. Turner's concern with the characteristics of local dress is manifest in the series of figure studies that also occur in this book. The particular Normandy headwear he notes here appears in a number of coloured drawings, for example the 'Interior of a French Cottage' (cat. no. 64).

78 *Rotterdam to Venice* sketchbook 1840
Figures on a hillside
Pencil
149 × 89 $(5\frac{7}{8} \times 3\frac{1}{2})$
Turner Bequest; CCCXX ff. 29 verso, 30
D32318, D32319

The treatment of this sheet, comprising a topographical view supported by small supplementary studies at the base of the page, is typical of Turner's use of his sketchbooks at this date. The figure studies indicate the details of local dress and it is significant that such notes are of continuing relevance to his purposes. While in the watercolour studies of the period figures are indicated in a summary fashion, it is apparent that they were based on a prior knowledge of carefully observed detail.

Bibliography

John Barrell, *The Dark Side of the Landscape*, 1980

Rev. Stopford Brooke, *Notes on the Liber Studiorum*, 1885

J. B. Bullen, 'Thomas Hardy and Turner', *Turner Society News*, no. 50, November 1988, pp. 11–14

Martin Butlin and Evelyn Joll, *The Paintings of J. M. W. Turner*, 1984 (revised edition)

Martin Butlin, Ian Warrell and Mollie Luther, *Turner at Petworth*, 1989

Alasdair Clayre (ed), *Nature and Industrialization*, 1977

Stephen Daniels, 'The Implications of Industry: Turner and Leeds', *Turner Studies*, summer 1986, vol. 6, no. 1, pp. 10–17

Phyllis Deane, *The First Industrial Revolution*, 1965

Bernard Falk, *Turner The Painter: His Hidden Life*, 1938

Dennis Farr, *William Etty*, 1958

A. J. Finberg, *A Complete Inventory of the Turner Bequest*, 1909

A. J. Finberg, *Turner's Sketches and Drawings*, 1910

A. J. Finberg, *The History of Turner's 'Liber Studiorum' with a new catalogue raisonée*, 1924

A. J. Finberg, *The Life of J. M. W. Turner*, 2nd ed., 1967

John Gage, 'Turner's Academic Friendships: C. L. Eastlake', *Burlington Magazine*, vol. 110, Dec. 1968, pp. 677–685

John Gage (ed), *The Collected Correspondence of J. M. W. Turner, with an Early Diary and a Memoir by George Jones*, 1980

John Gage, *Turner: a wonderful range of mind*, 1987

Alexander Gilchrist, *Life of William Etty*, 2 vols, 1855

Robin Hamlyn, 'Turner and the Royal Academy'. *Turner en France* catalogue, pp. 609–616

Robin Hamlyn, 'An Early Sketchbook by J. M. Turner's, *Record of The Art Museum Princeton University*, 1985, vol. 44, no. 2, pp. 2–23

S. C. Hutchison, 'The Royal Academy Schools, 1768–1830', *Walpole Society*, 1962, vol. 38, p. 123 ff

E. L. Jones, *The Development of English Agriculture 1815–1873*, 1968

Michael Kitson, 'Turner and Rembrandt', *Turner Studies*, summer 1988, vol. 8, no. 1, pp. 2–19

Jack Lindsay, *J. M. W. Turner: a critical Biography*, 1966

Peter Mathias, *The First Industrial Revolution*, 2nd ed. 1983

R. A. C. Parker, *Enclosures in the Eighteenth Century*, 1960

Curtis Price, 'Turner at the Pantheon Opera House 1791–2', *Turner Studies*, winter 1987, vol. 7, no. 2, pp. 2–8

W. G. Rawlinson, *Turner's 'Liber Studiorum'*, 1906

W. G. Rawlinson, *The Engraved Work of J. M. W. Turner, R. A.*, 2 vols, 1908

John Russell & Andrew Wilton, *Turner in Switzerland*, 1976

John Ruskin, *Works* (Library Edition), ed. Sir. E. T. Cook & A. Wedderburn, 39 vols., London 1903–12

Eric Shanes, *Turner's Picturesque Views in England and Wales, 1825–1838*, with an introduction by Andrew Wilton, 1979

Eric Shanes, *Turner's Rivers, Harbours and Coasts*, 1981

Sam Smiles, Picture Notes on Turner's 'St Mawes' paintings, *Turner Studies*, summer 1988, vol. 8, no. 1, pp. 53–57

Selby Whittingham, 'What You Will: or some notes regarding the influence of Watteau on Turner and other British Artists (I)', *Turner Studies*, summer 1985, vol. 5, no. 1, pp. 2–24

Andrew Wilton, 'Sublime or Ridiculous? Turner and the Problem of the Historical Figure', *New Literary History*, 1984–5, vol. 16, pp. 343–376

Andrew Wilton, *The Life and Work of J. M. W. Turner*, 1979

Andrew Wilton, *Turner Abroad*, 1982

Andrew Wilton, *Turner in his time*, 1987

Andrew Wilton, *The 'Wilson' Sketchbook*, 1988

EXHIBITION CATALOGUES

Turner 1775–1851, exhibition at the Royal Academy, 1974

Turner in the British Museum, drawings and watercolours, catalogue of the exhibition at the Department of Prints and Drawings of the British Museum, with an introduction by Andrew Wilton, 1975

Turner en France, catalogue of the exhibition held at the Centre Culturel du Marais, Paris, 1981–2